BIZARRE
and
ORNAMENTAL
ALPHABETS

edited by

CAROL BELANGER GRAFTON

Dover Publications, Inc.
New York

Bibliographical Note

Bizarre and Ornamental Alphabets is a new work, first published by Dover
Publications, Inc., in 1981.

DOVER *Pictorial Archive* SERIES

International Standard Book Number
ISBN-13: 978-0-486-24105-0
ISBN-10: 0-486-24105-X

Library of Congress Catalog Card Number: 80-70327

Manufactured in the United States by Courier Corporation
24105X12
www.doverpublications.com

PUBLISHER'S NOTE

ecorative letters began as an integral part of a book's design—they served as the initial letters of paragraphs, chapters and headings, with the largest letters serving to mark off the most important divisions. Modern printers and designers no longer make such extensive use of decorative letters; they are now generally employed to create a special effect in advertising, a striking cover design, or as "spot" illustrations in a work printed in a simpler style.

The present anthology of 1,685 examples was selected to represent a wide variety, both historically and thematically, of ornamental and grotesque letters. They can be used directly, as they are, or can serve as a source of inspiration. Historically, the examples included here range from an Anglo-Celtic alphabet of the eleventh century (page 2) right up through the present.

While some of the alphabets are traditional in their approach, others are unique, leaving an unforgettable impression. The architectural alphabet (pages 84–91) is a rare combination of disciplines; one cannot fail to be amused by the groupings of animals that form the alphabet on page 66 or by the whimsical creatures of which the alphabet on page 82 is composed. And, since these alphabets must serve a variety of purposes, the selection encompasses both extraordinarily florid expressions, such as those on pages 36–59, and the firm, bold strokes of the alphabets on pages 96–100.

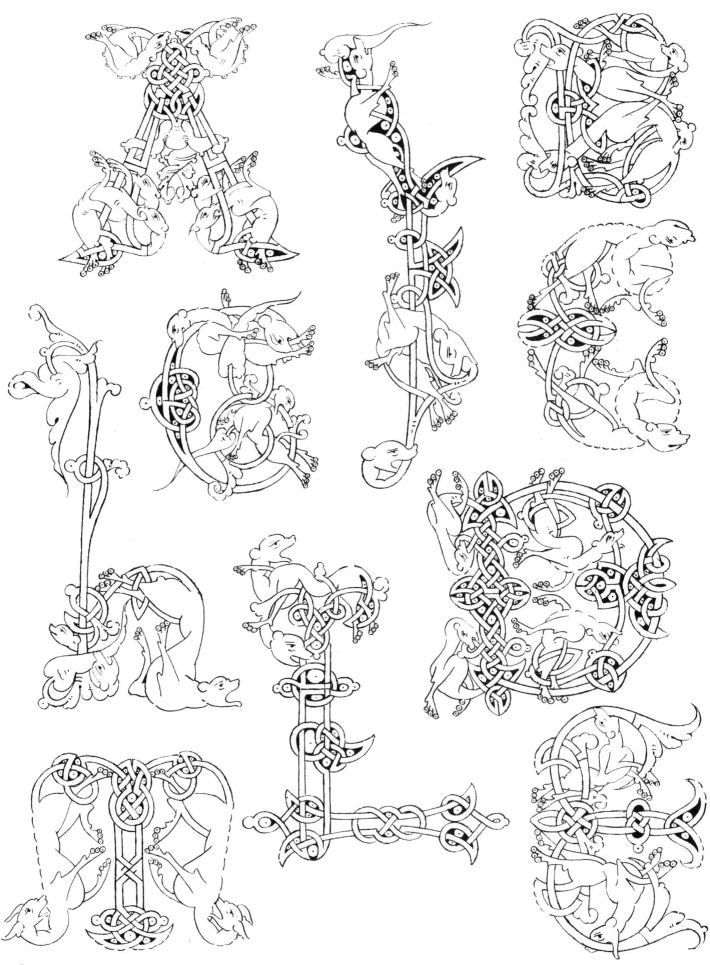

2

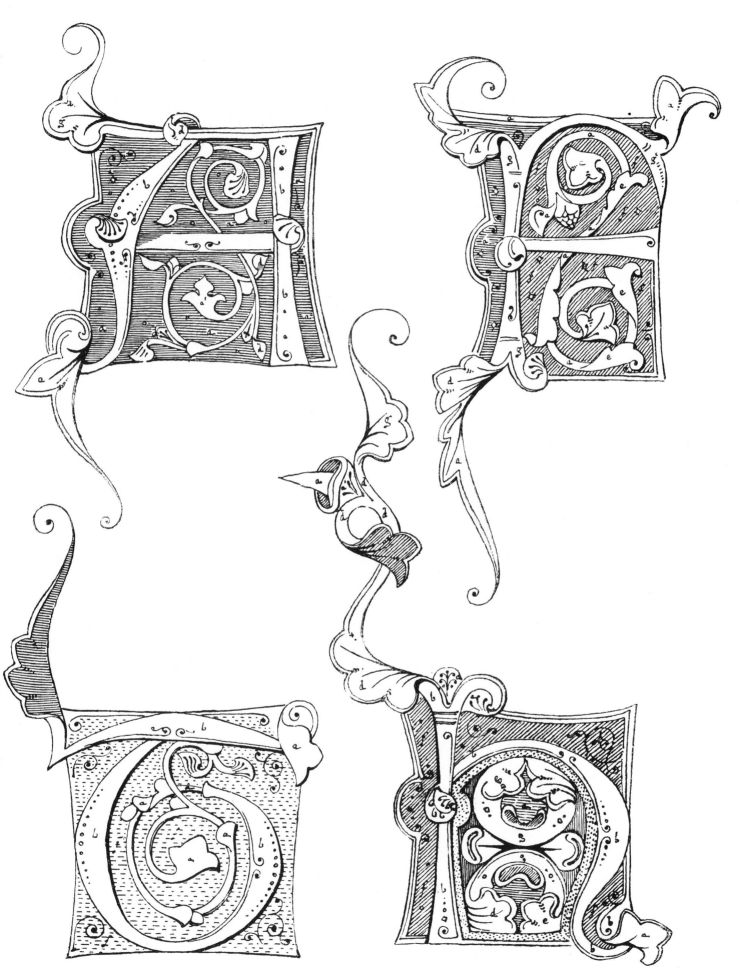

3

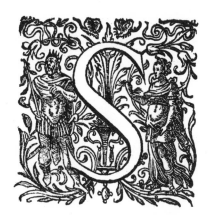
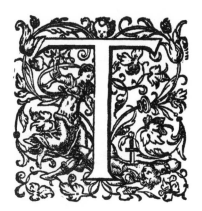

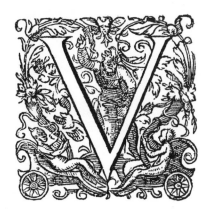
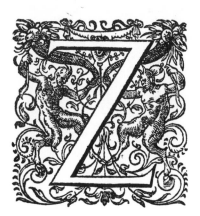

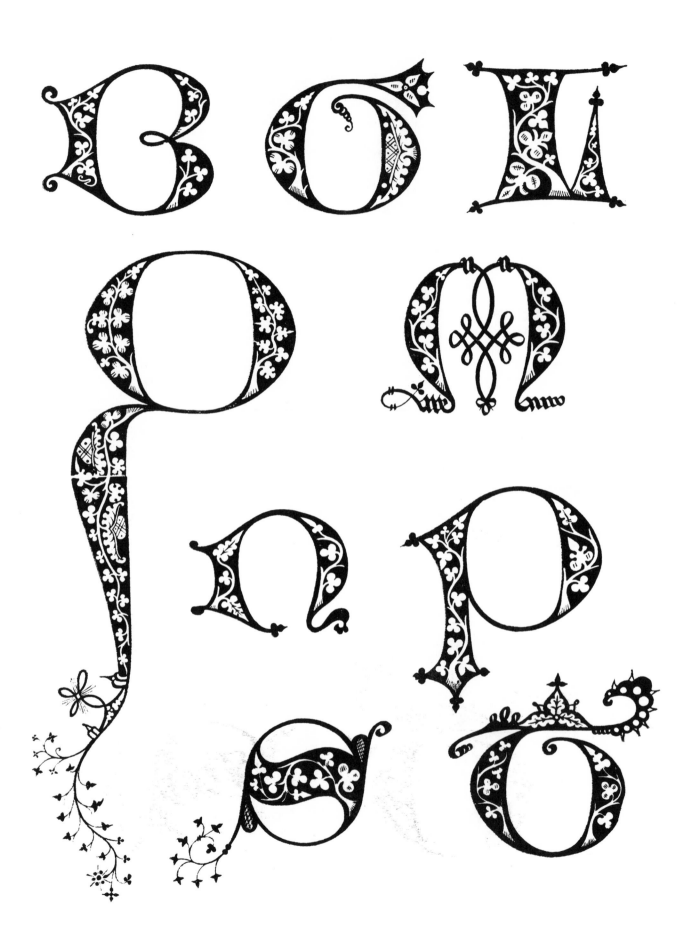

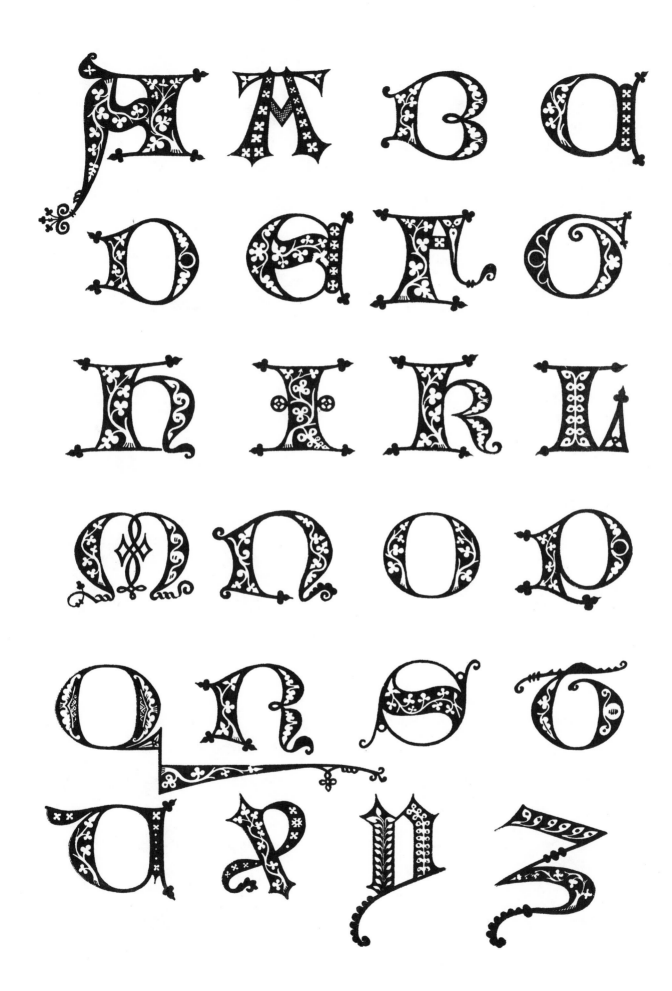

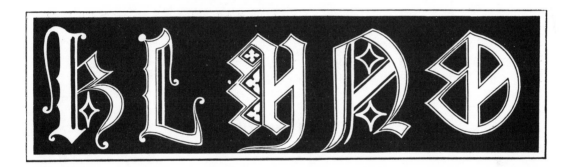

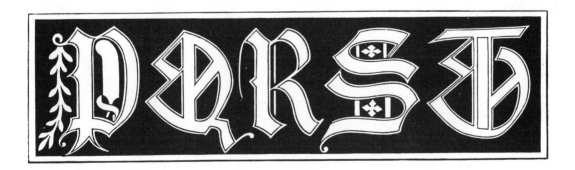

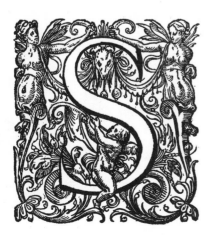

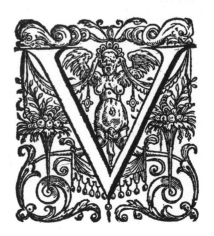

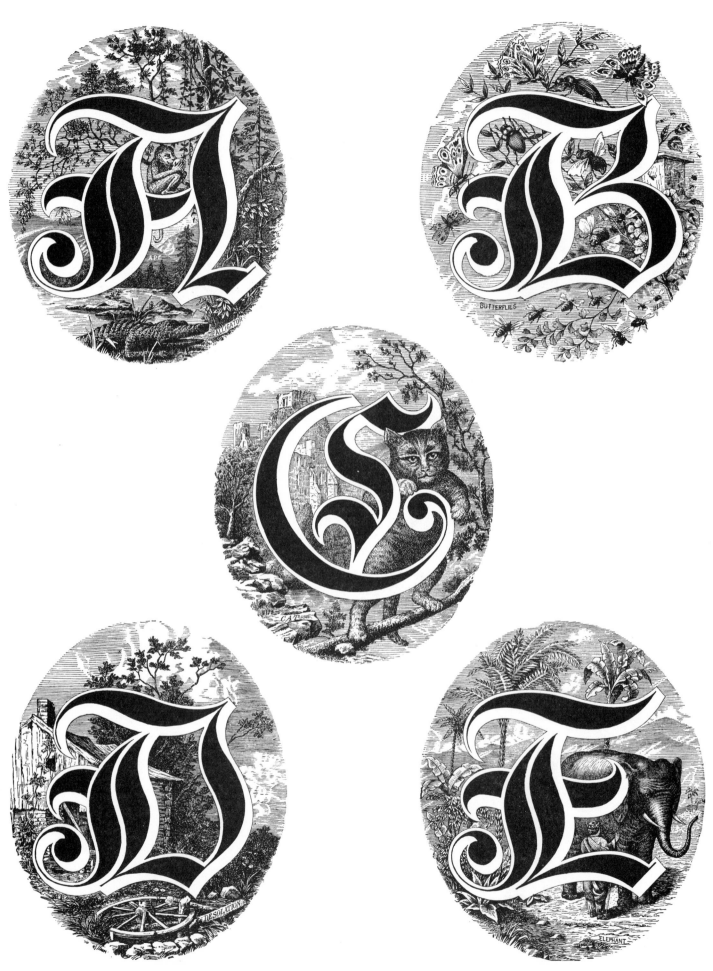

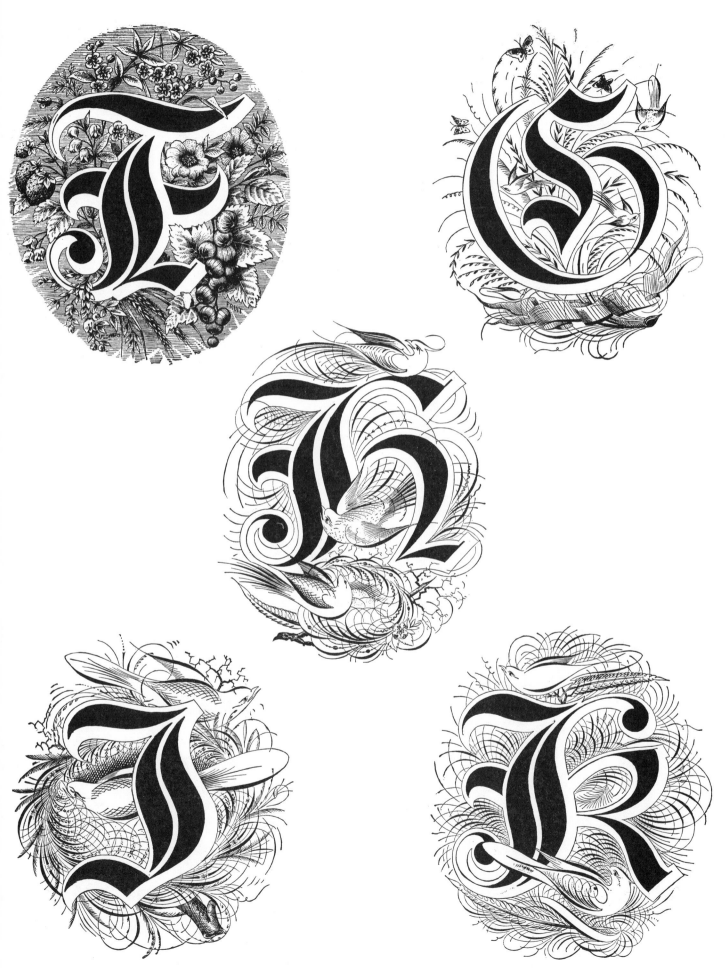

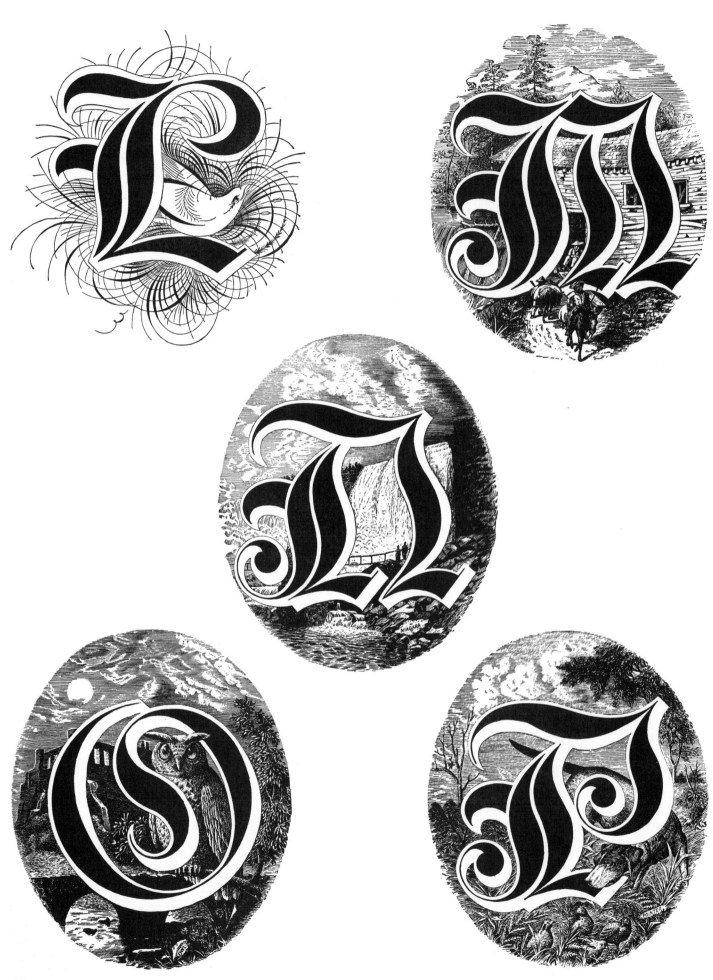

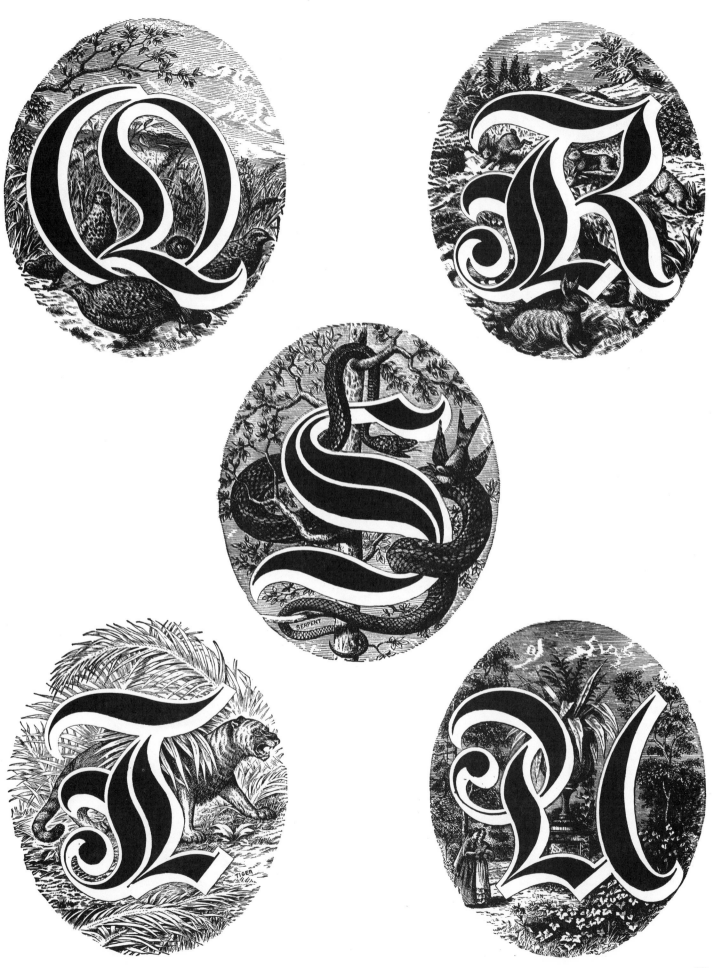

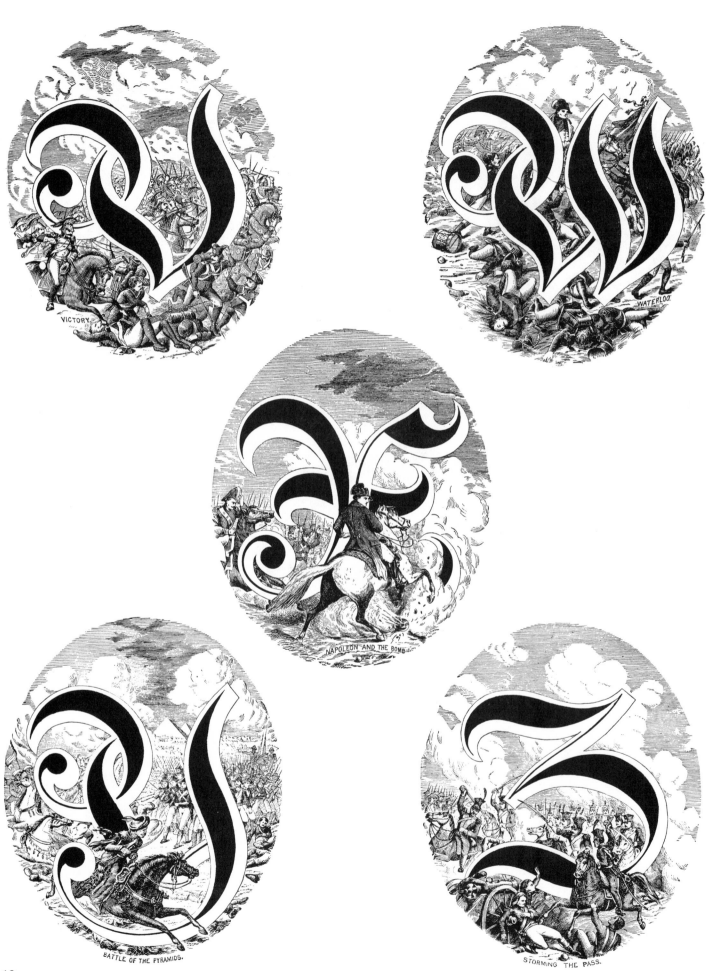

VICTORY

WATERLOO

NAPOLEON AND THE BOMB

BATTLE OF THE PYRAMIDS.

STORMING THE PASS.

19

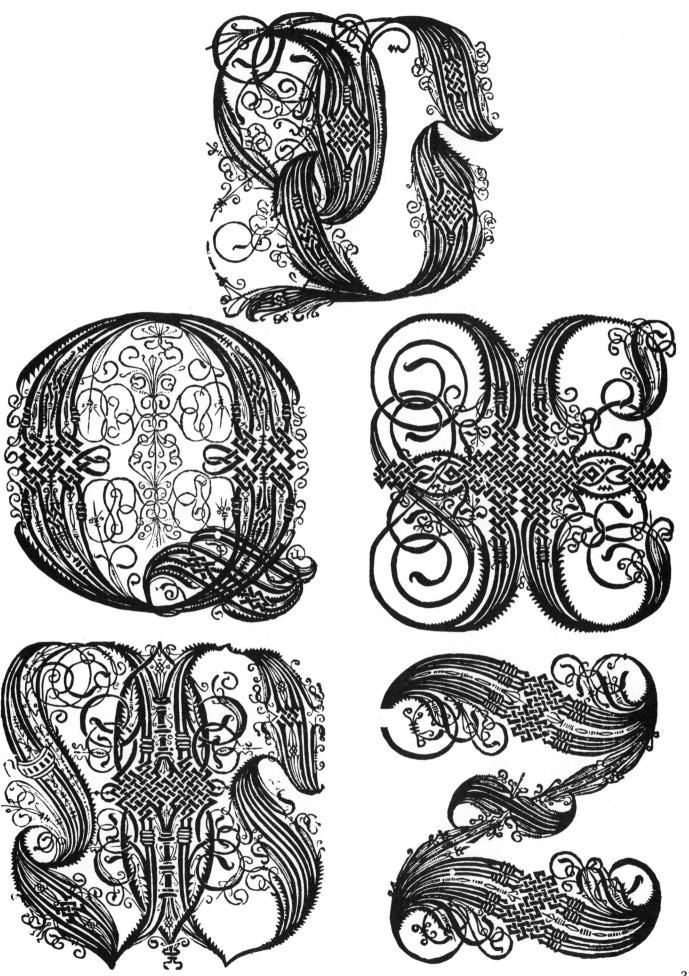

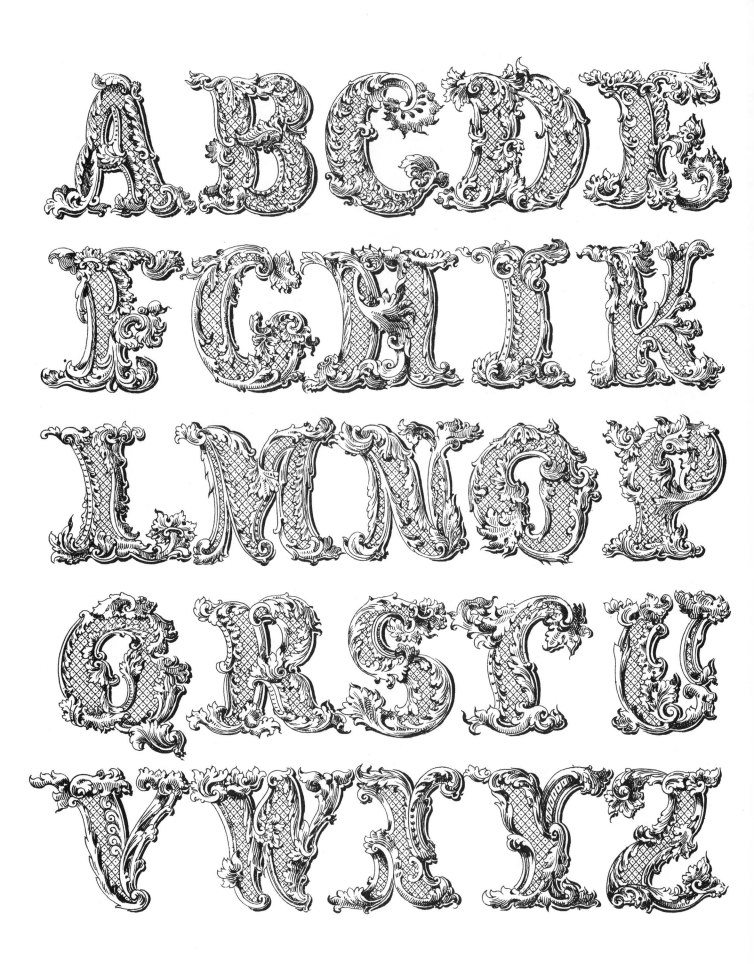

ABCDE
FGH
IJKLMN
OPQRS
TUVX
YZ

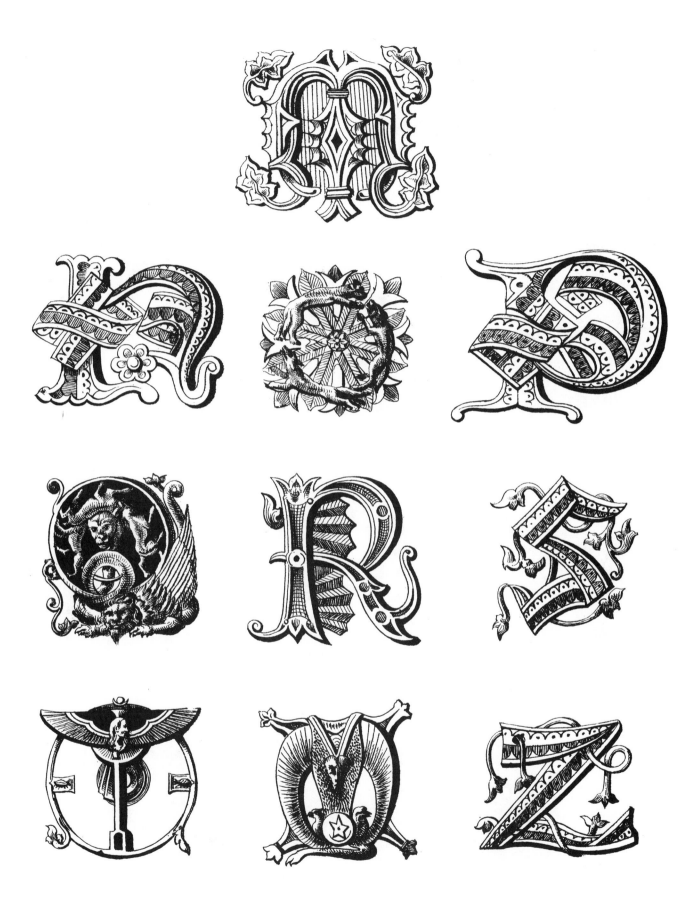

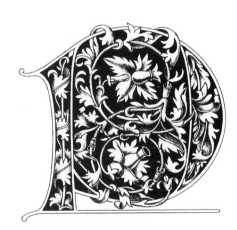

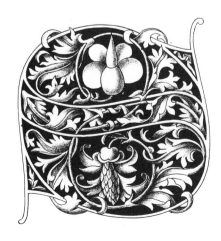
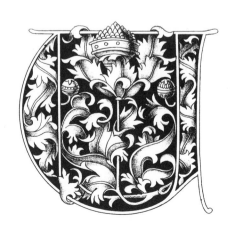

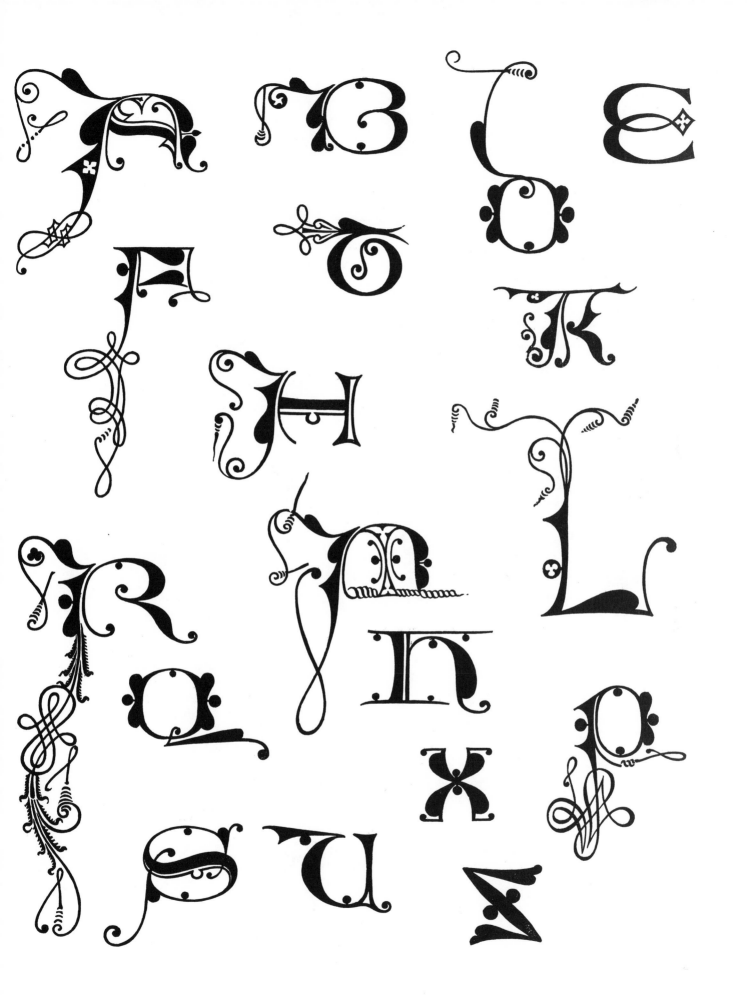

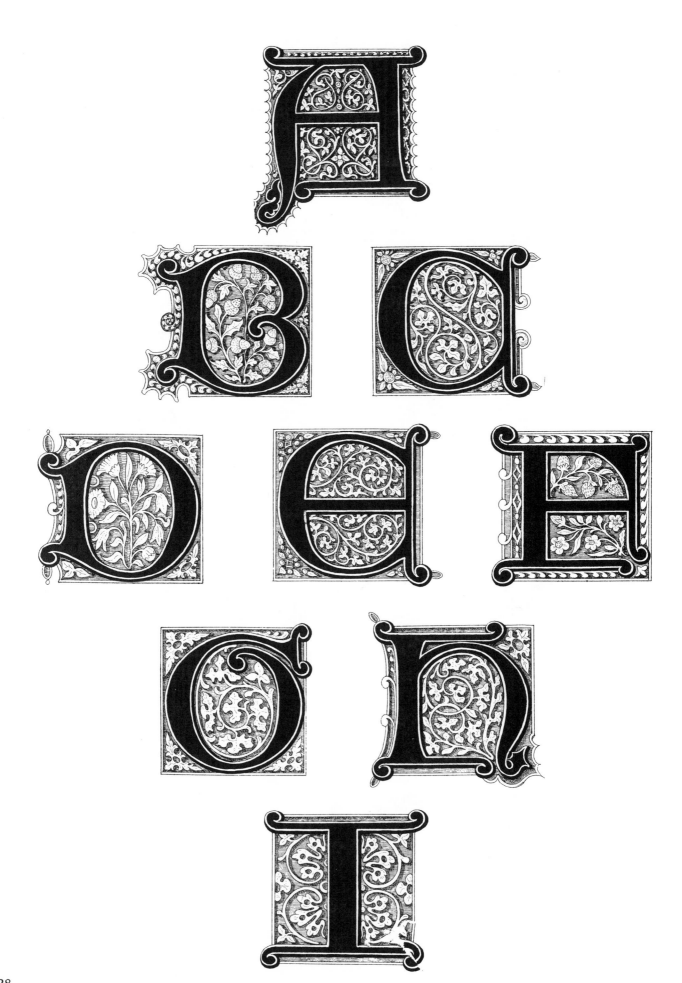

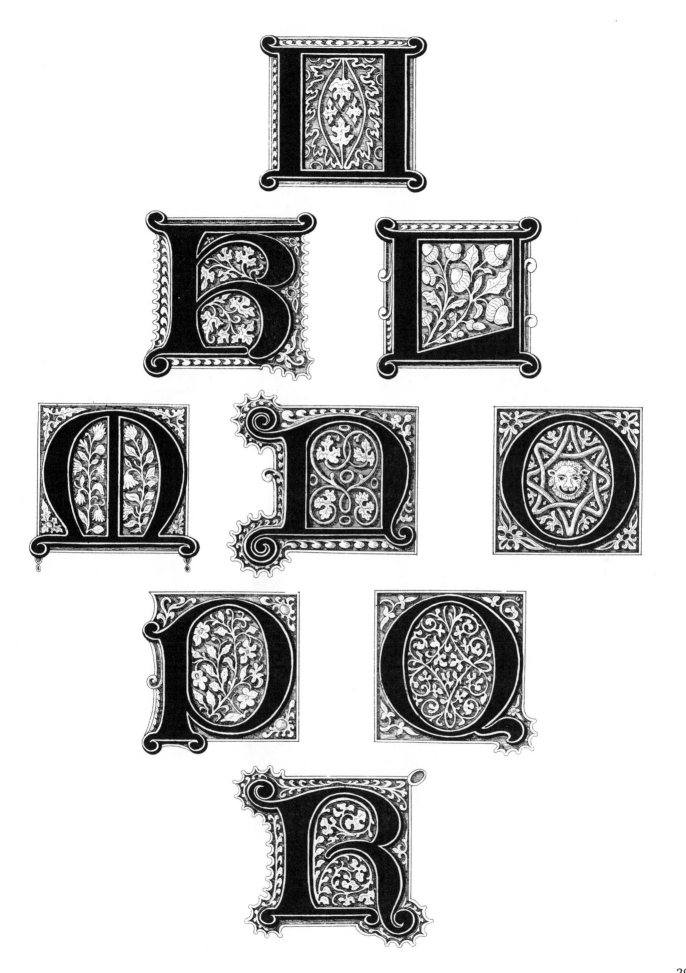

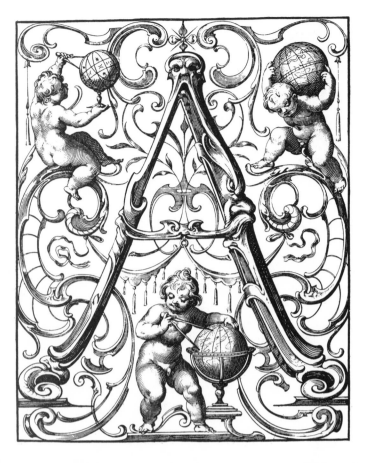

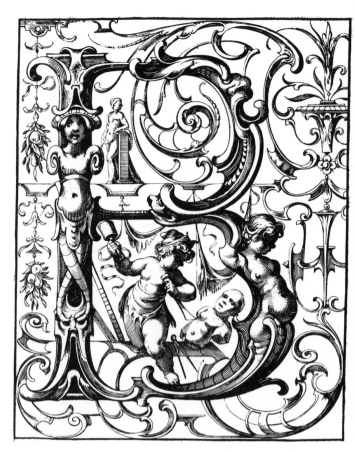

33

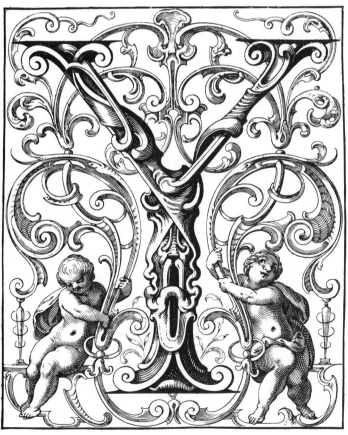

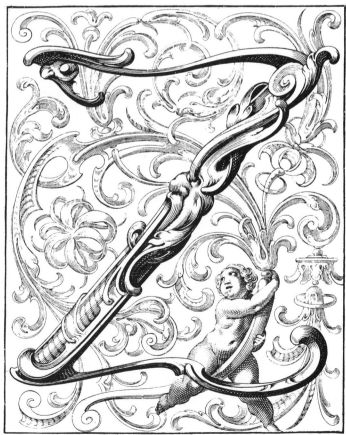

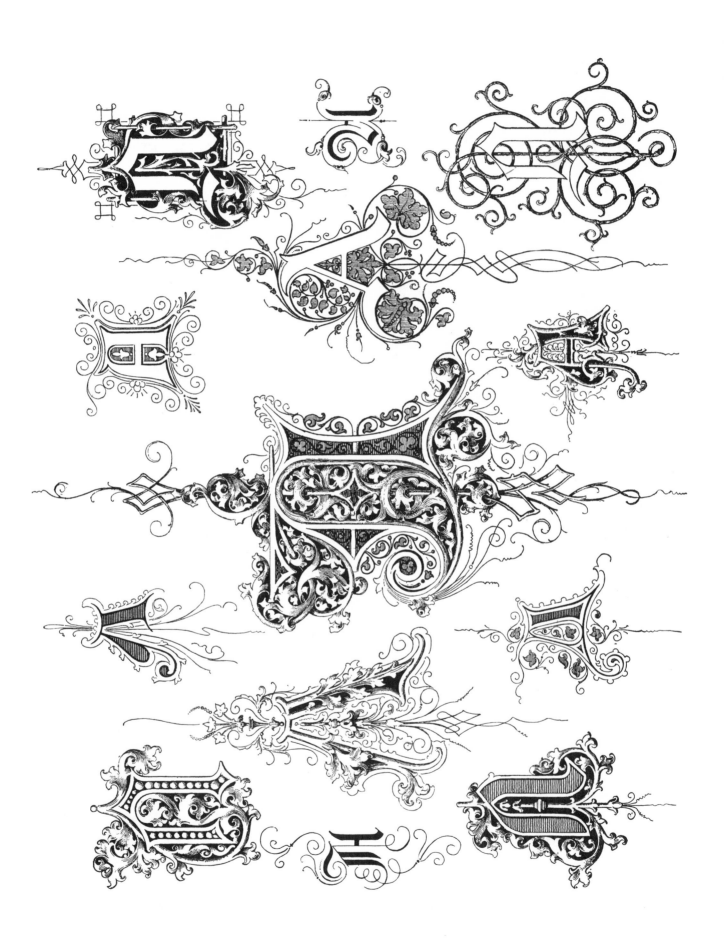

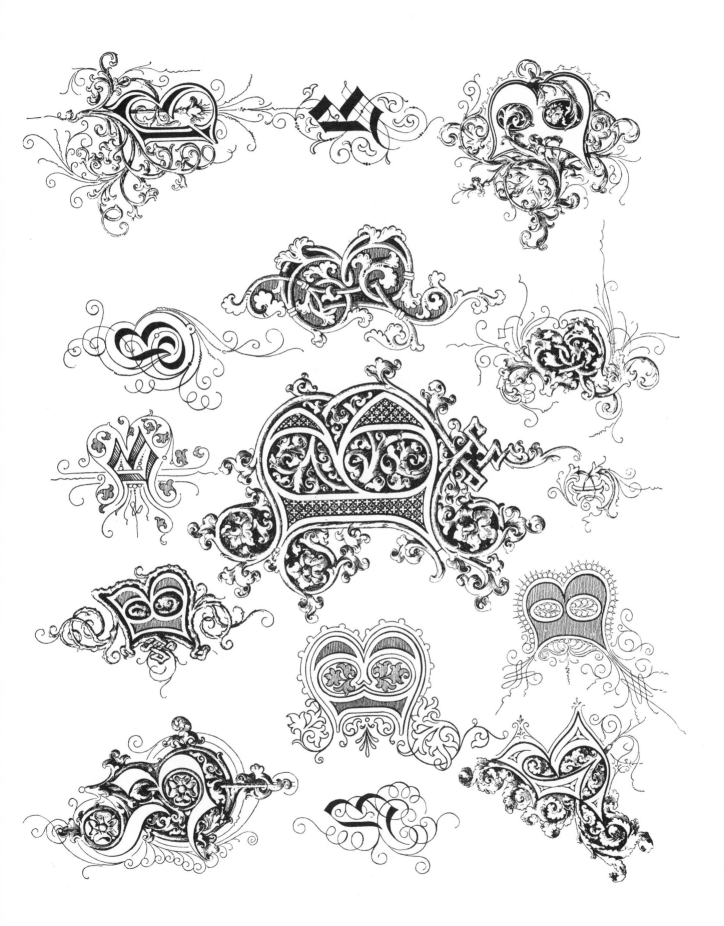

38

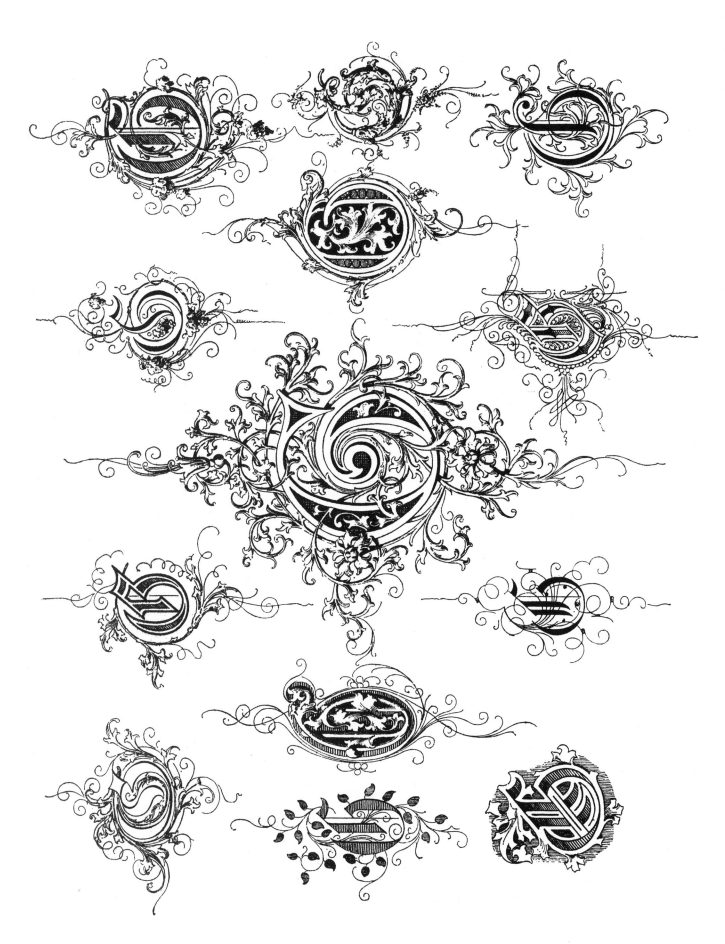

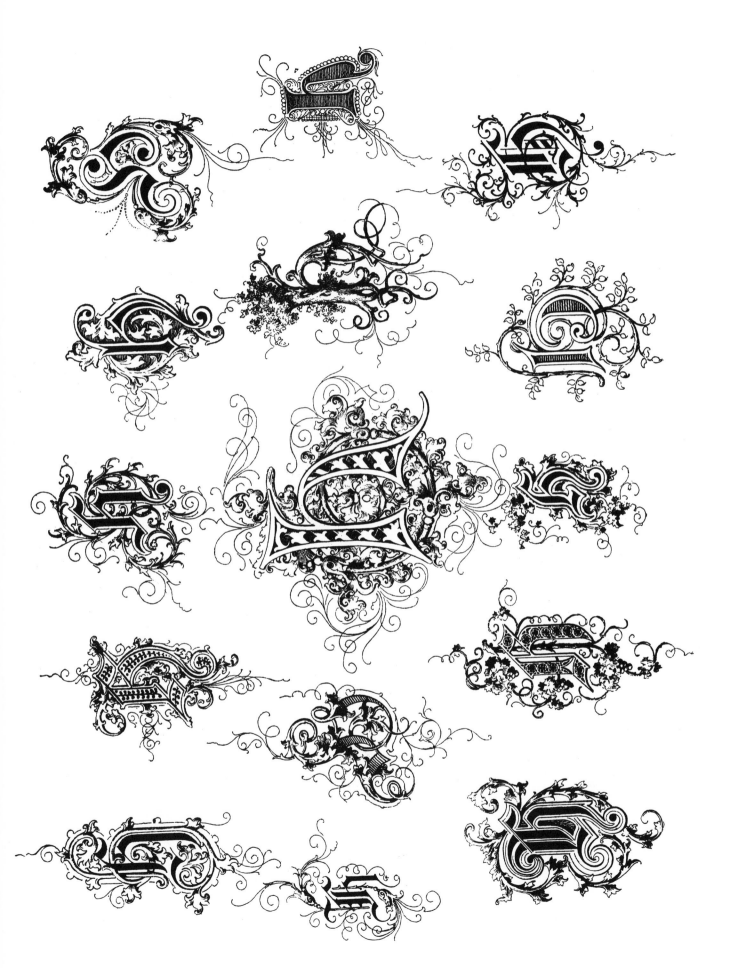

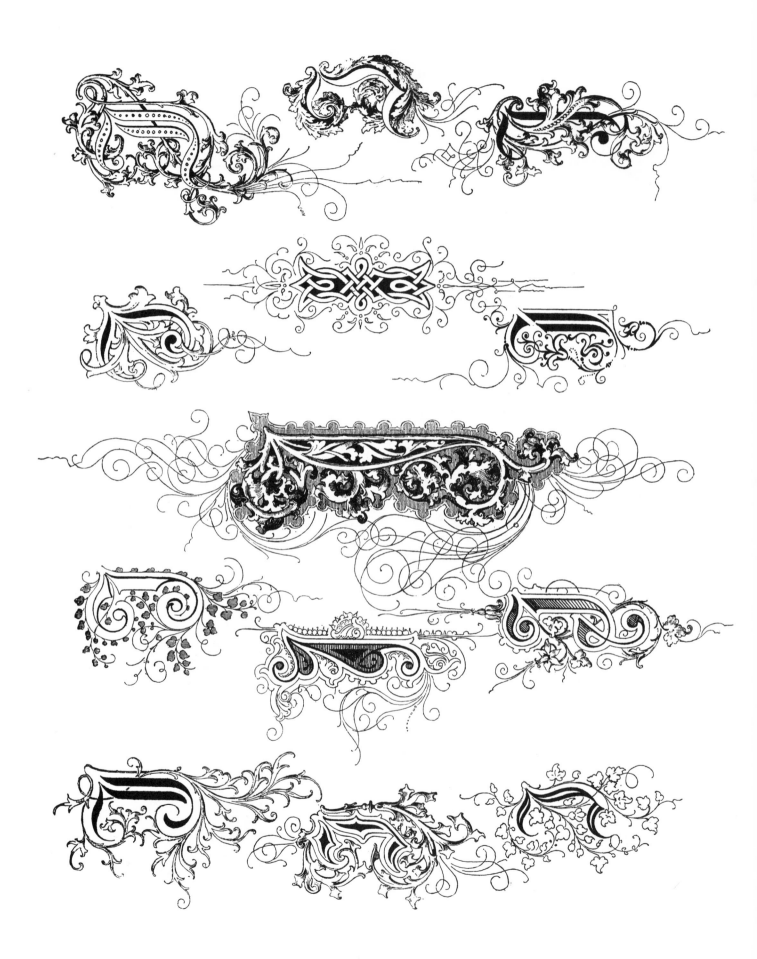

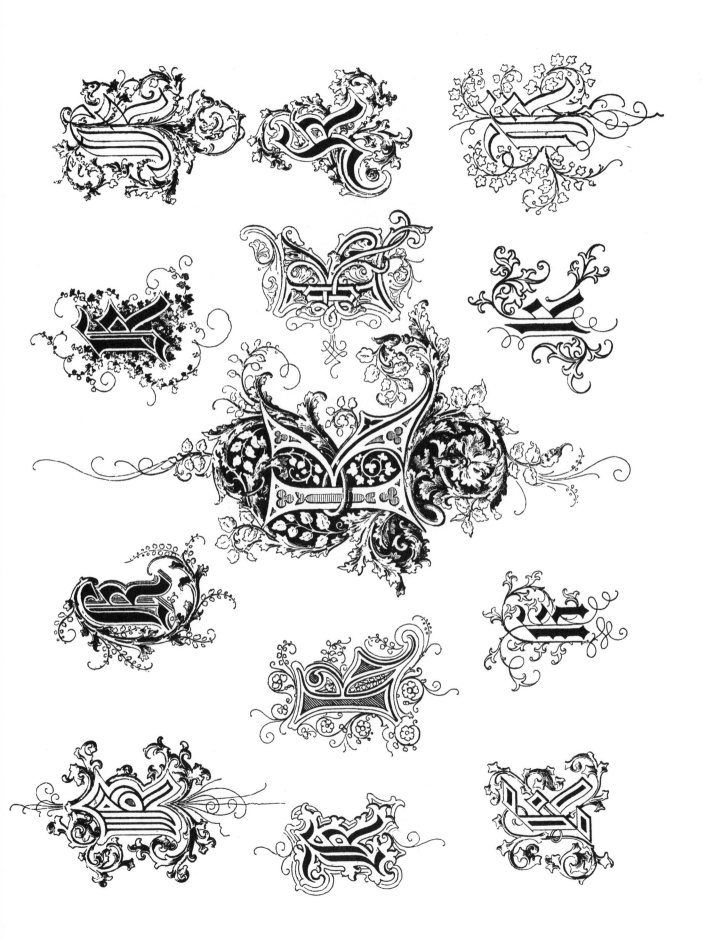

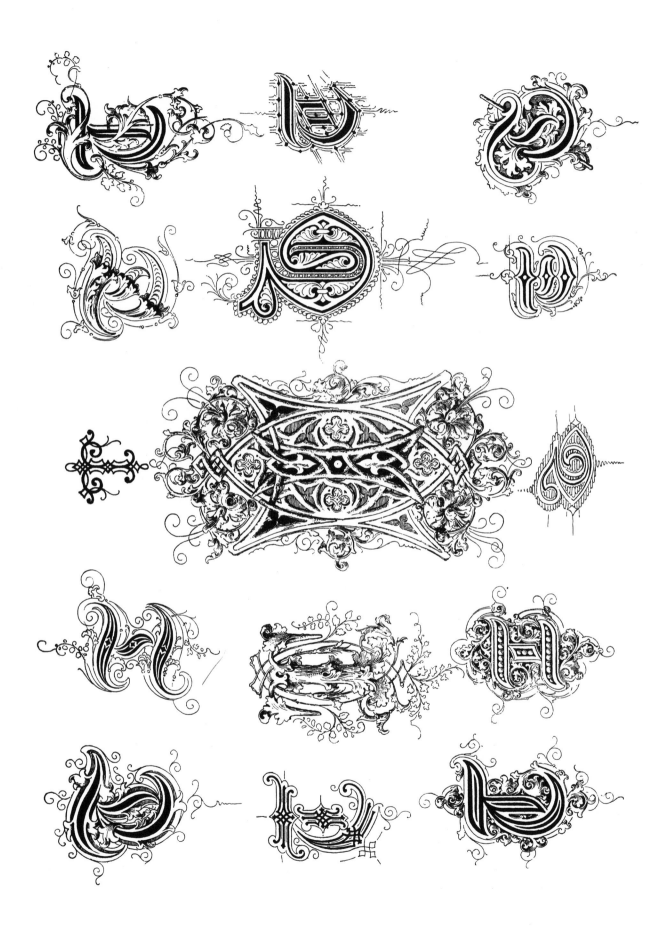

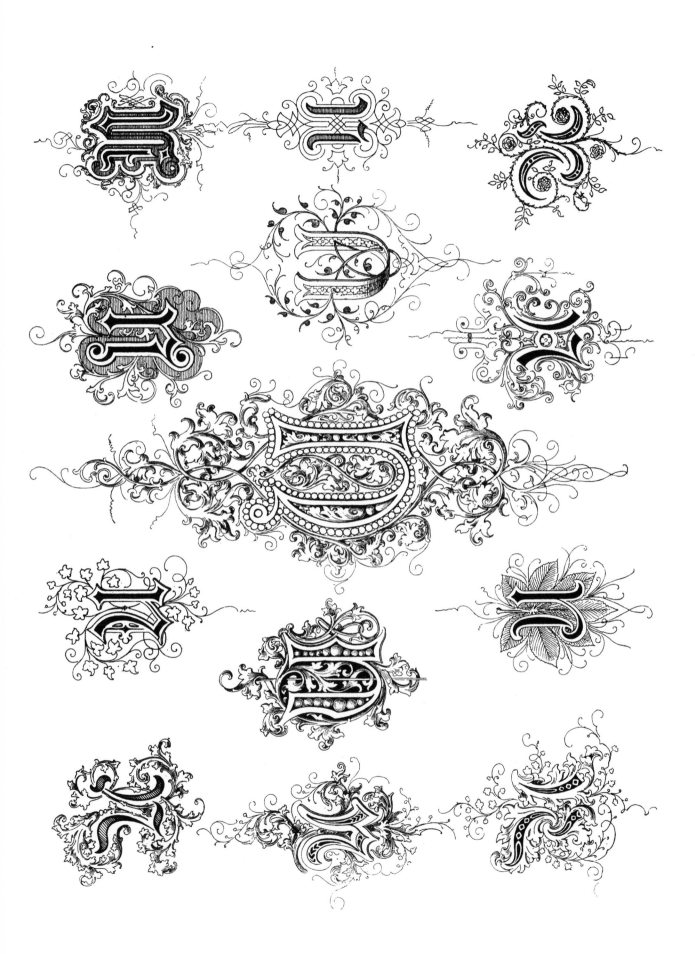

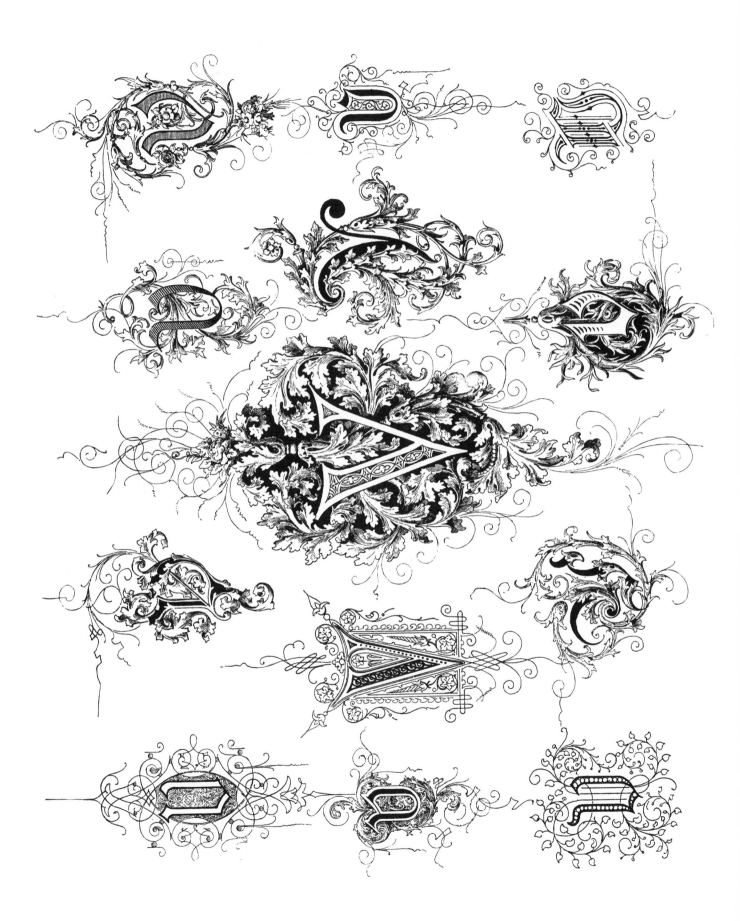

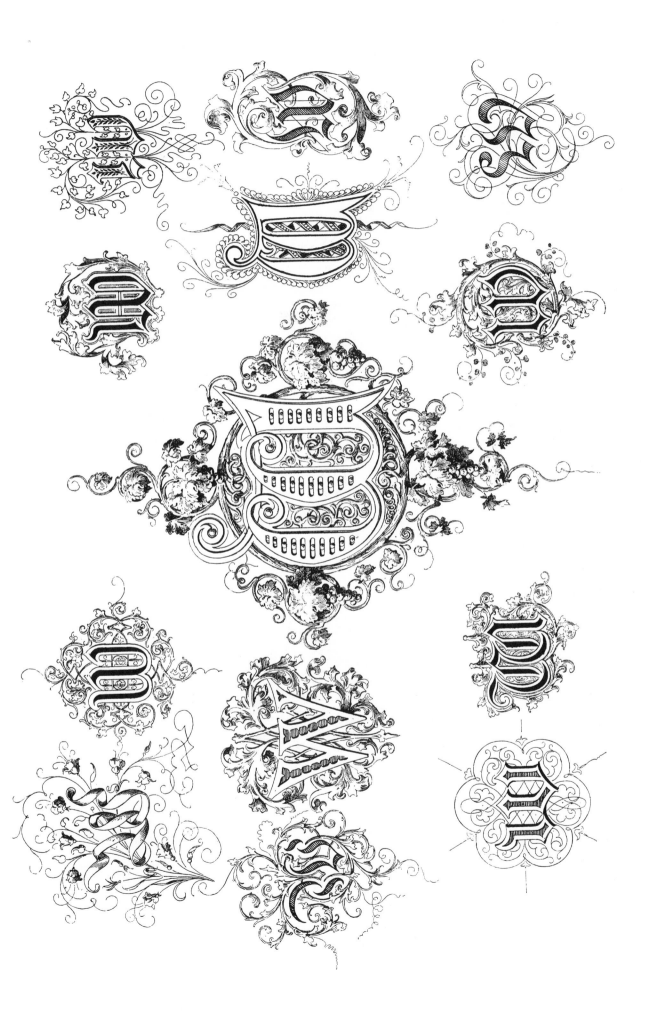

58

59

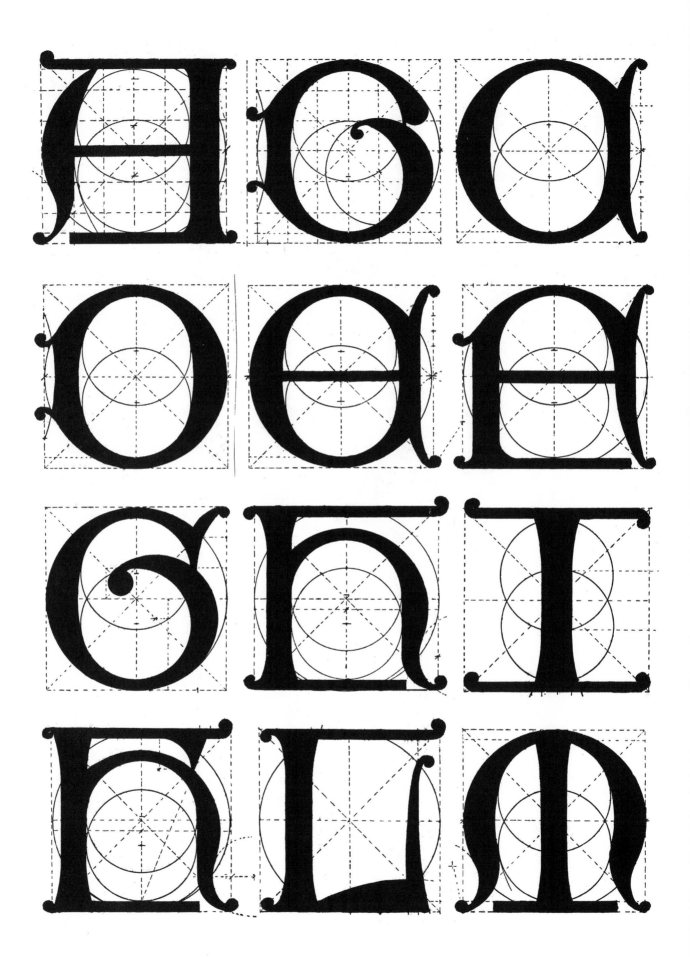

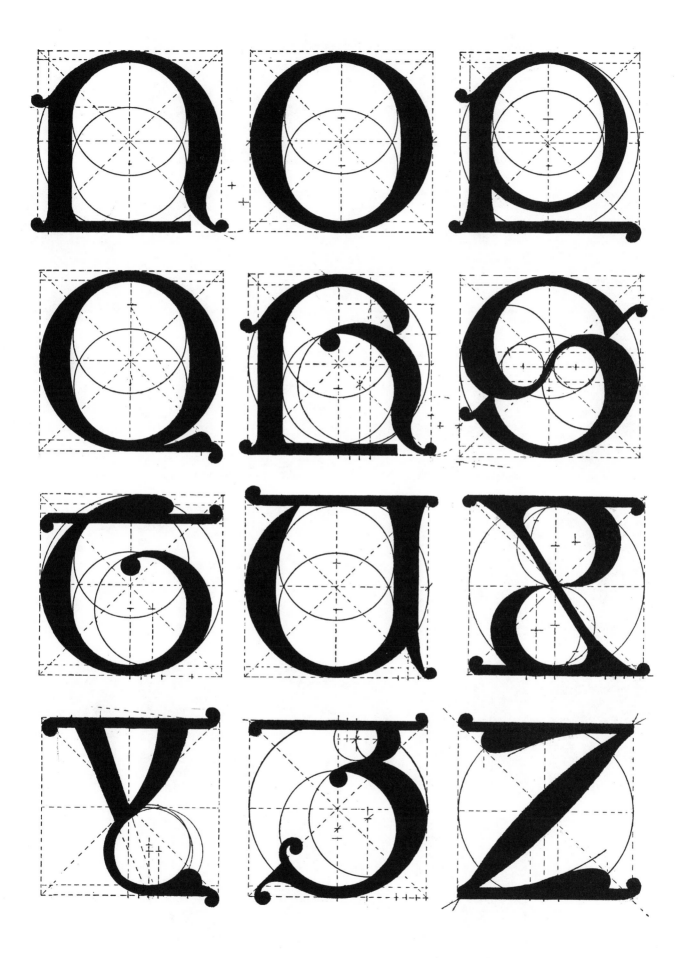

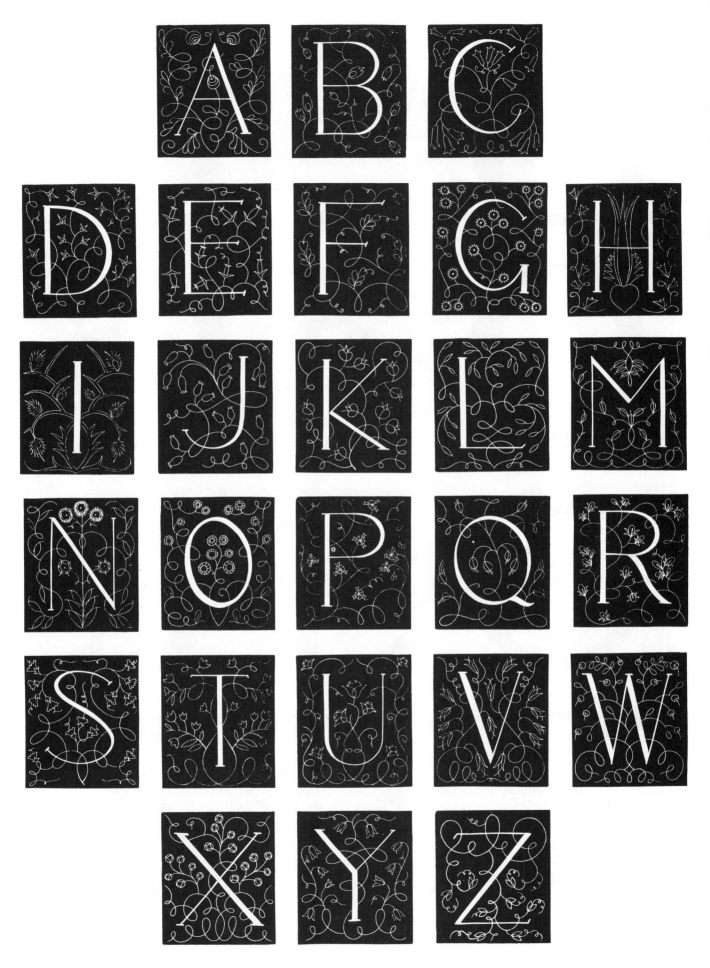

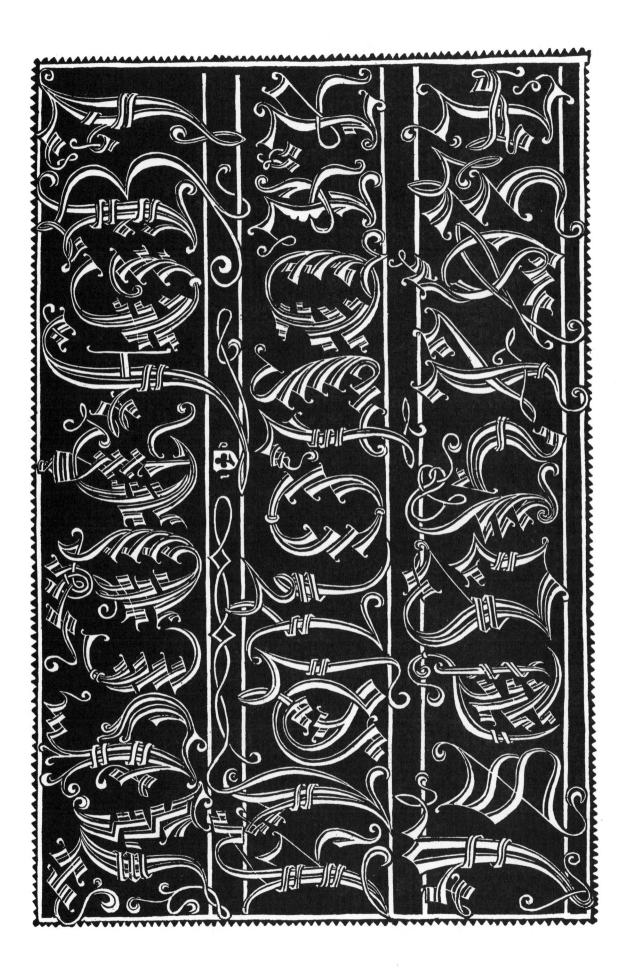

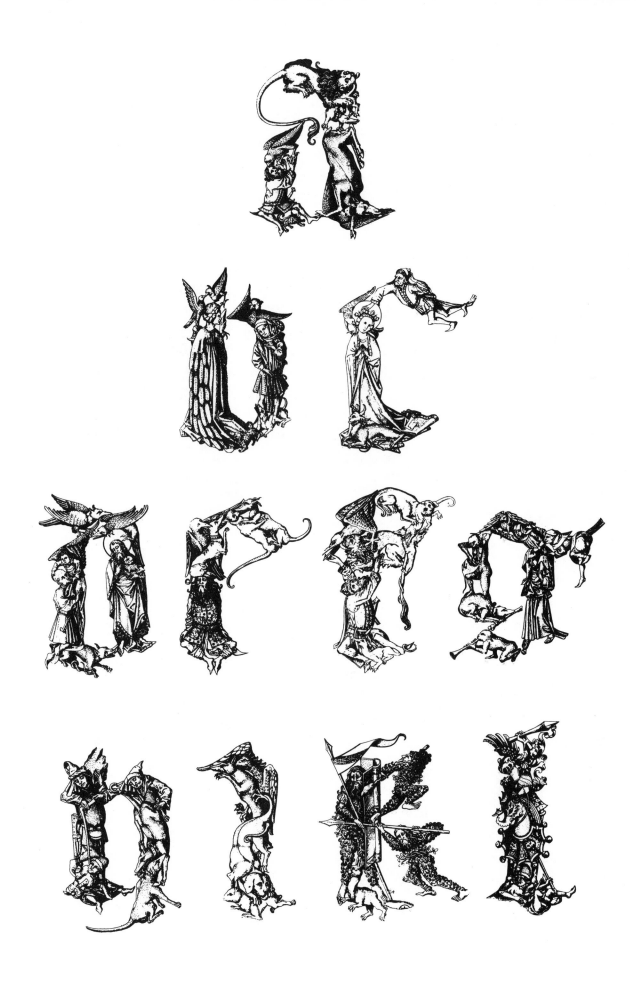

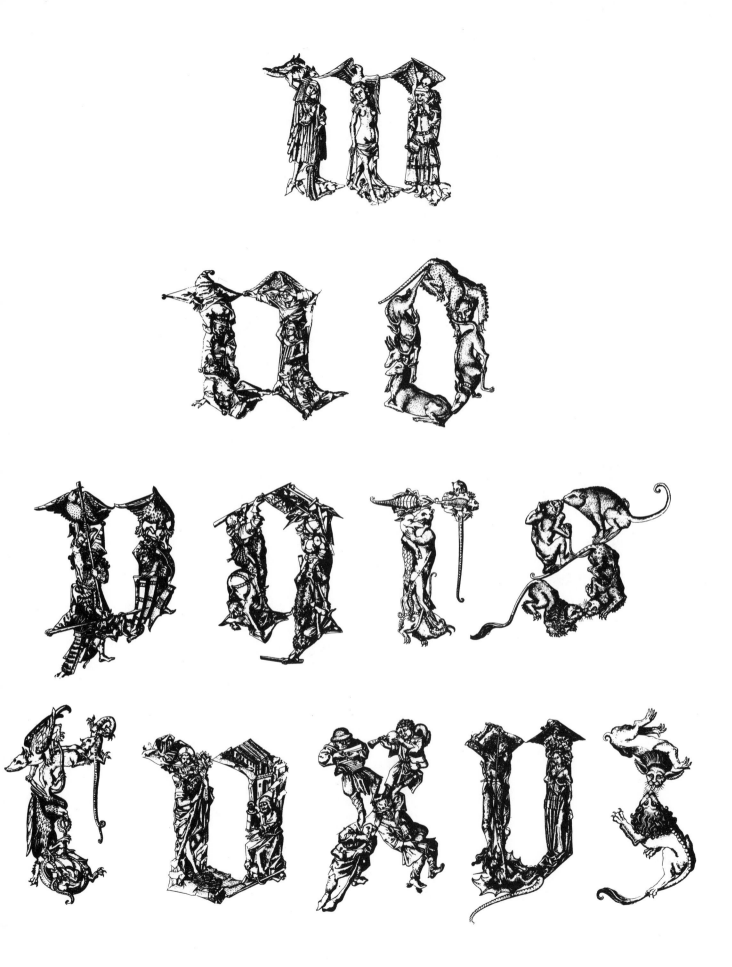

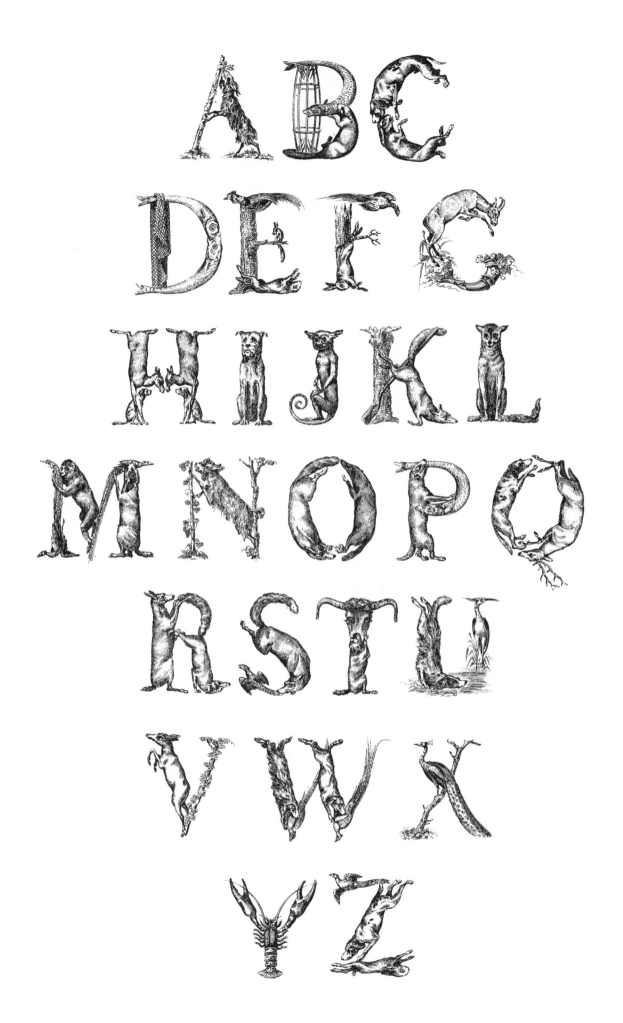

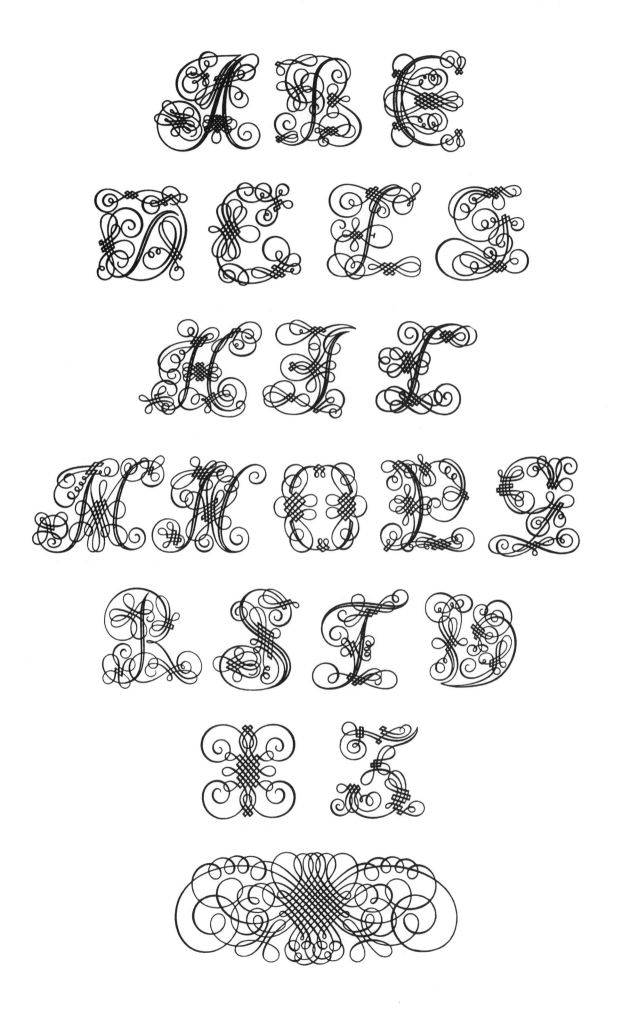

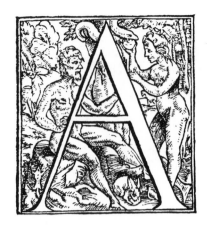

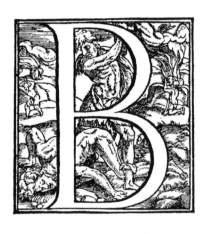

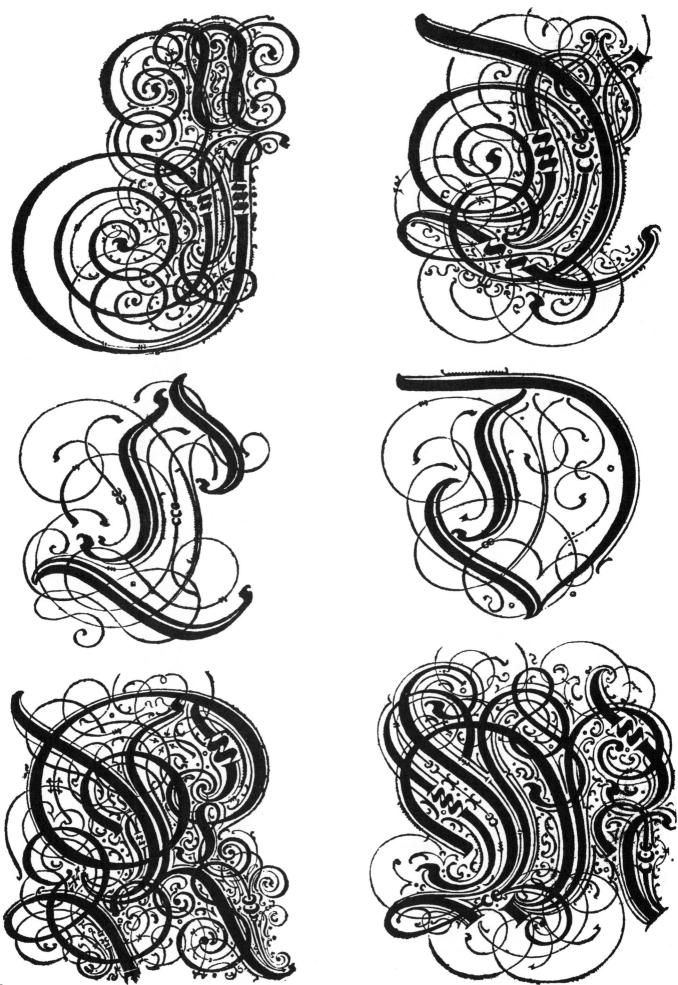

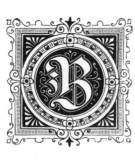 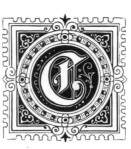 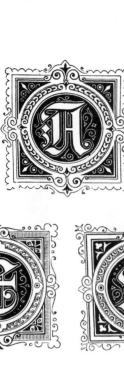

 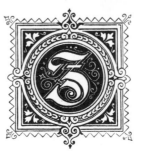

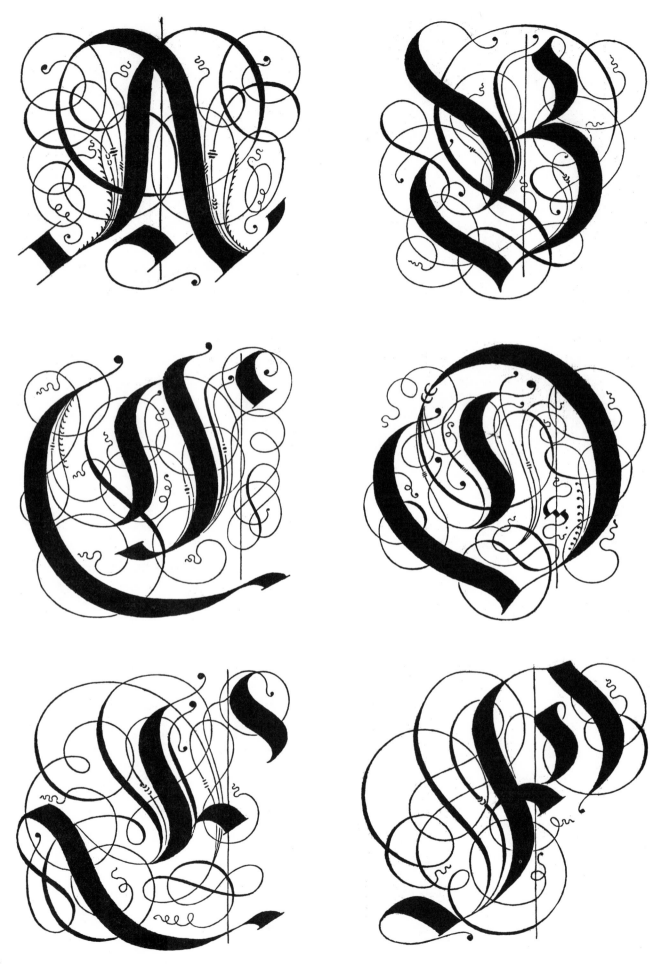

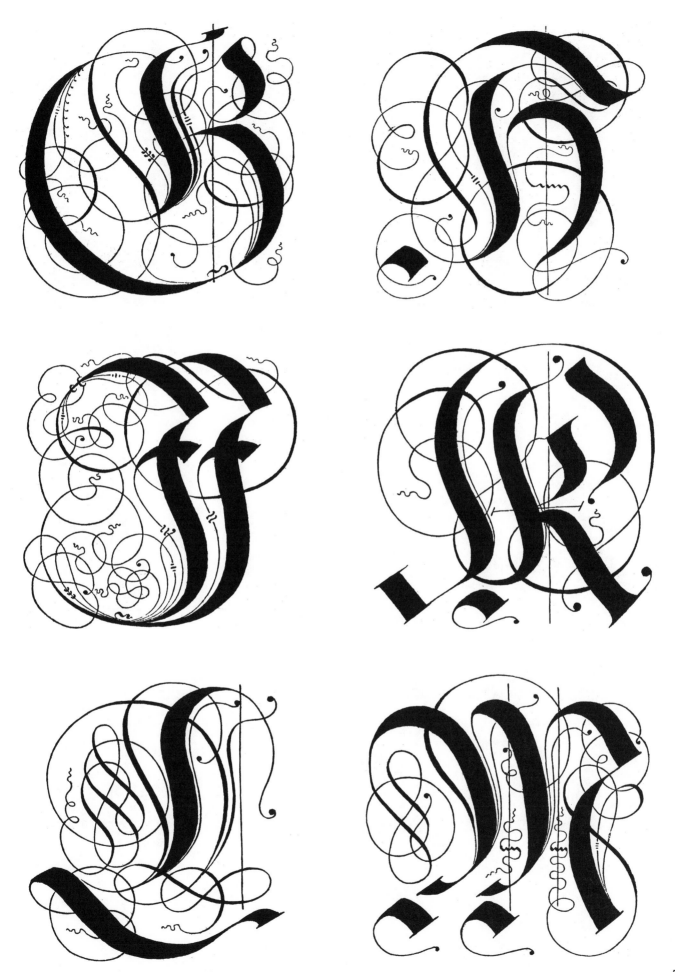

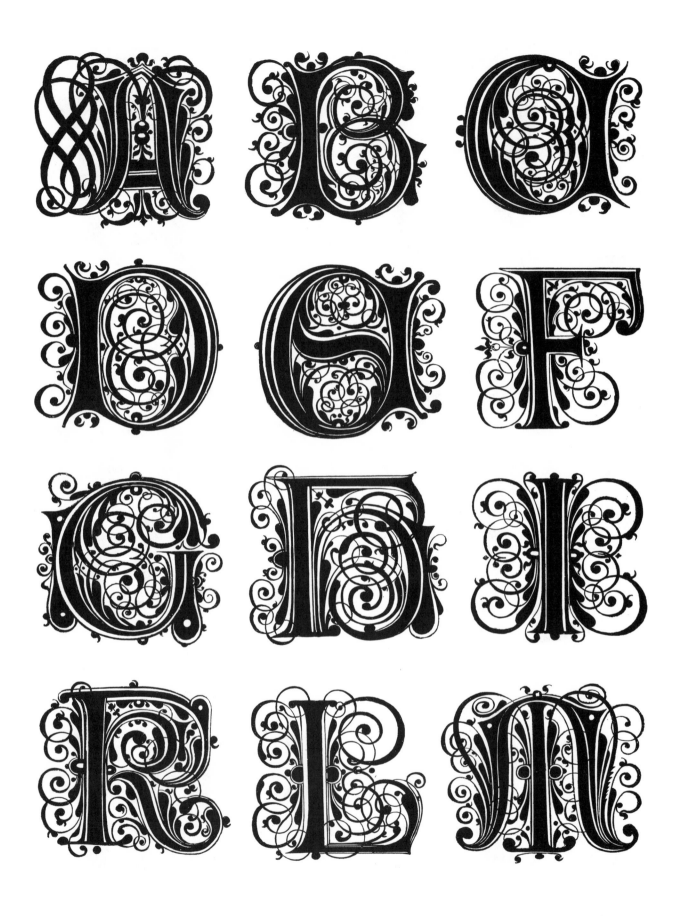

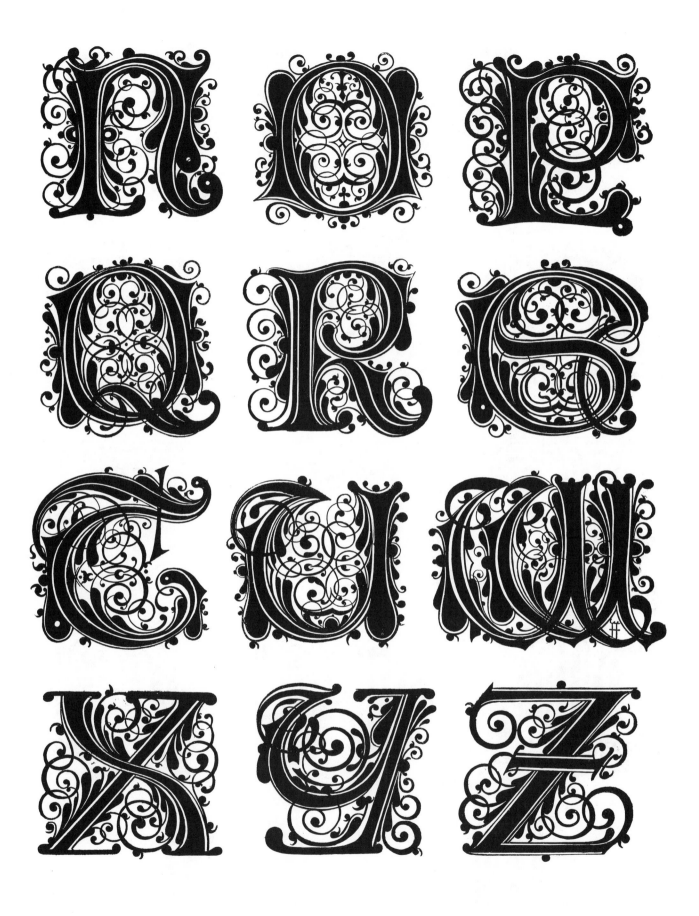

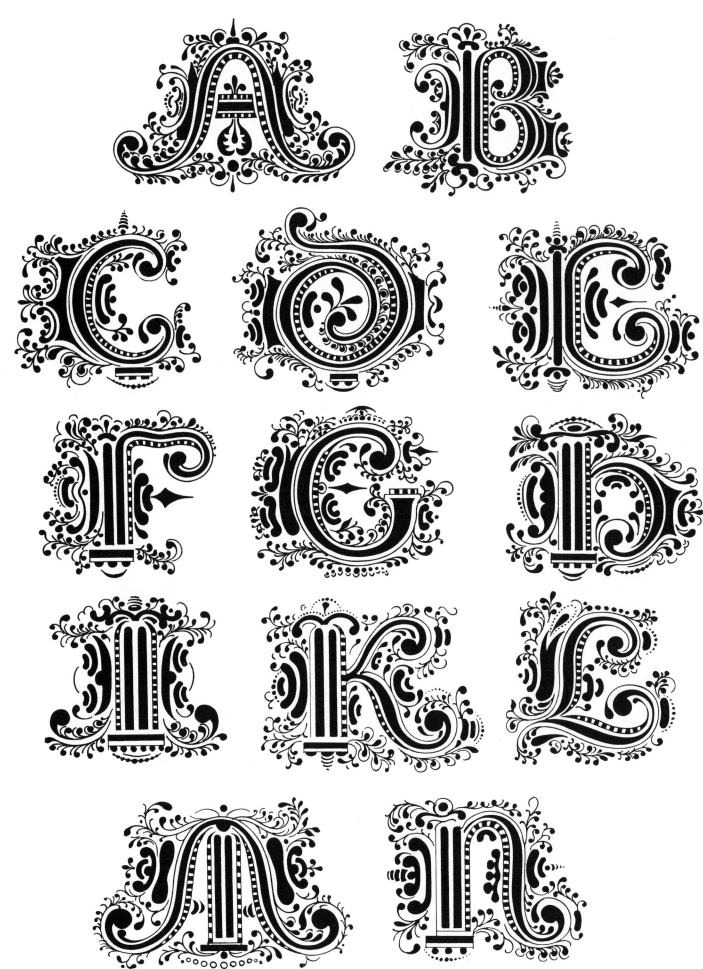

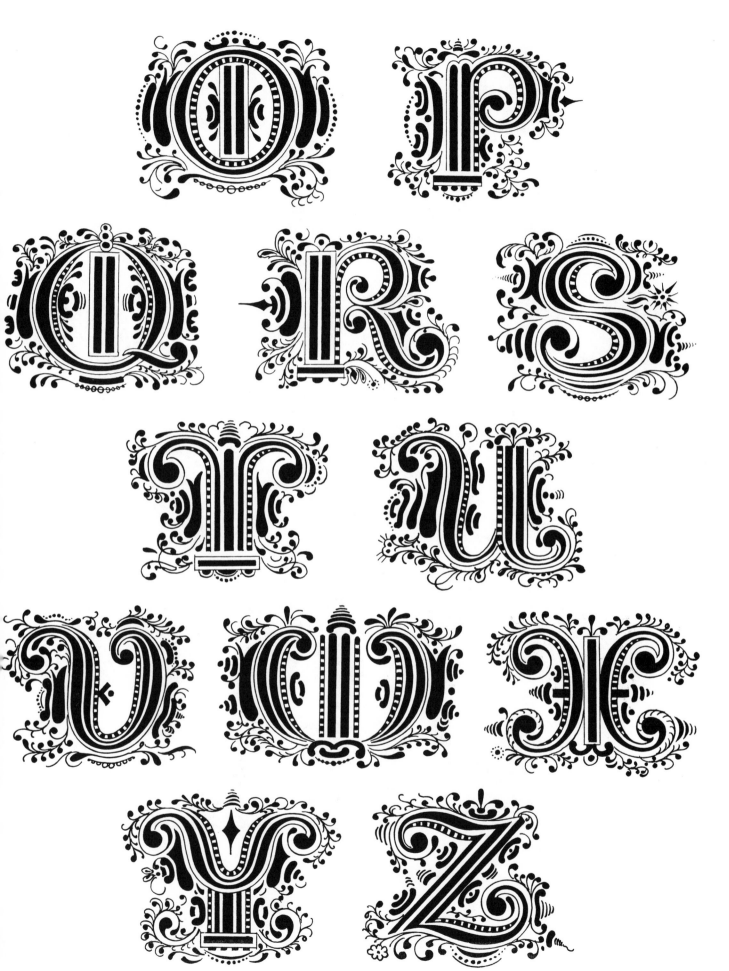

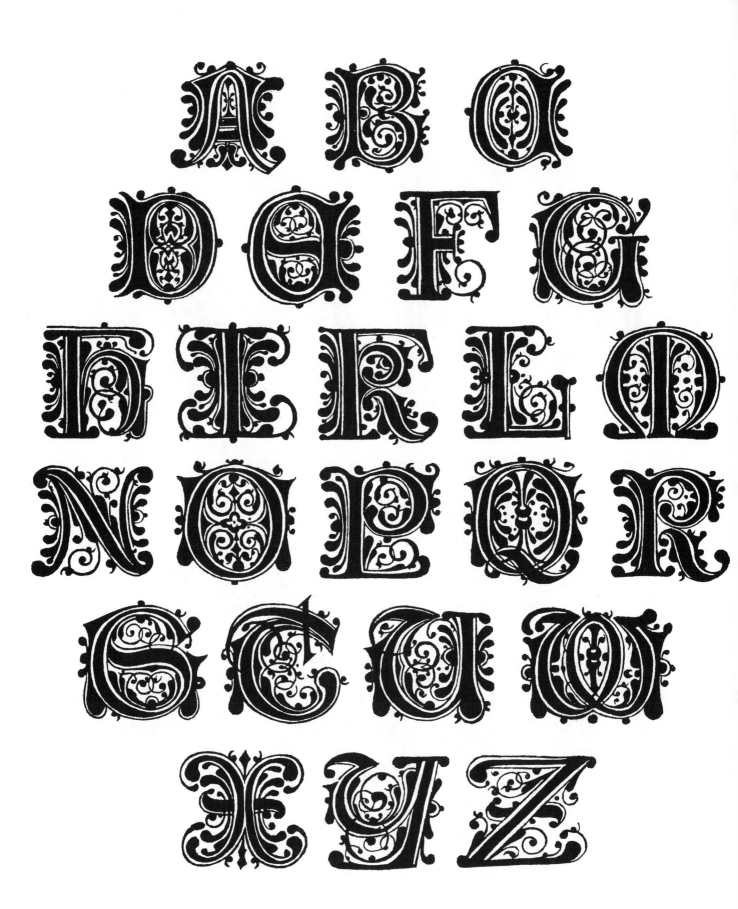

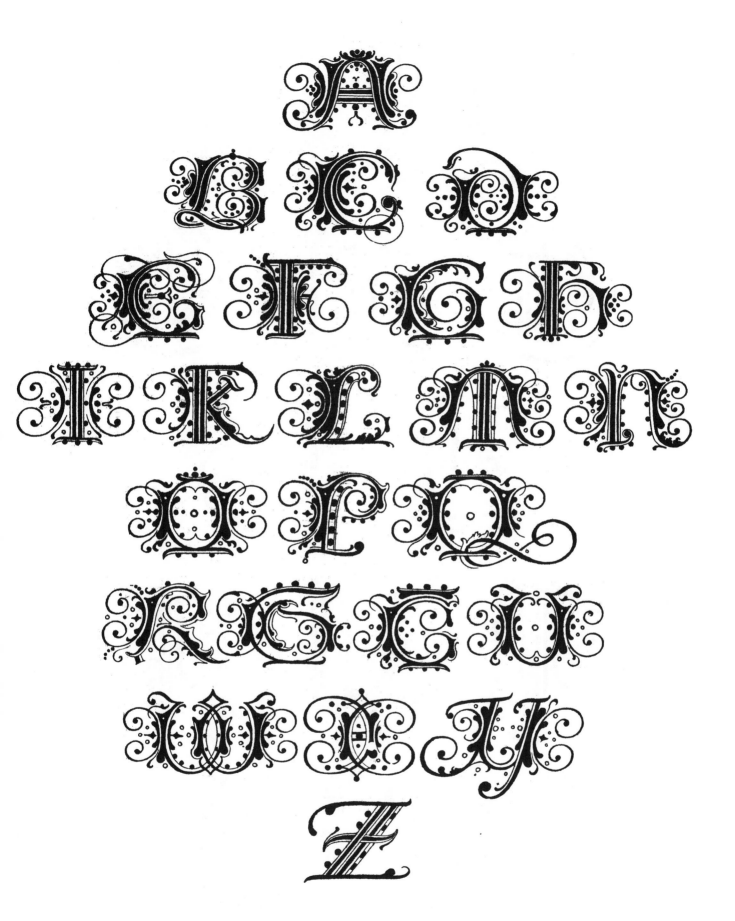

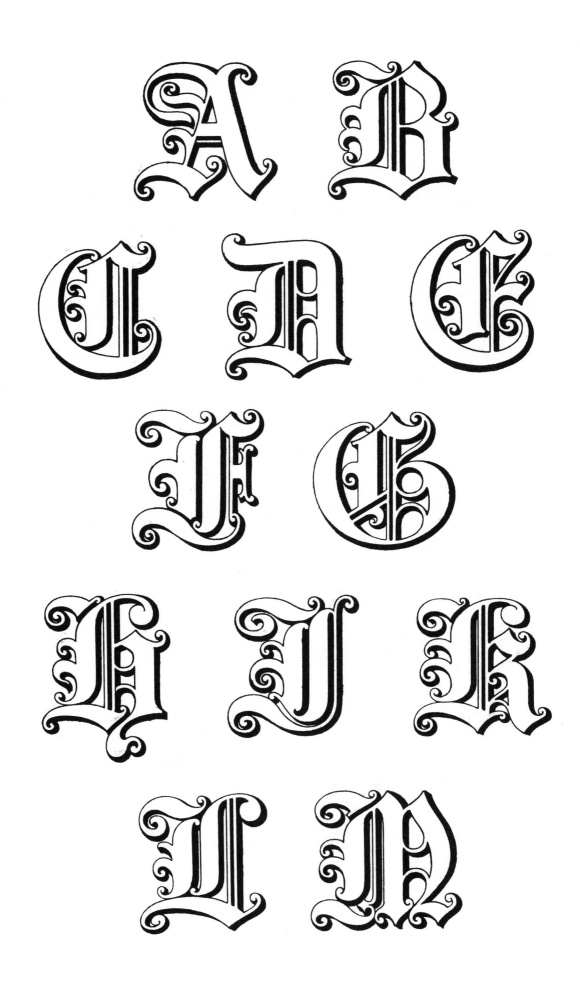

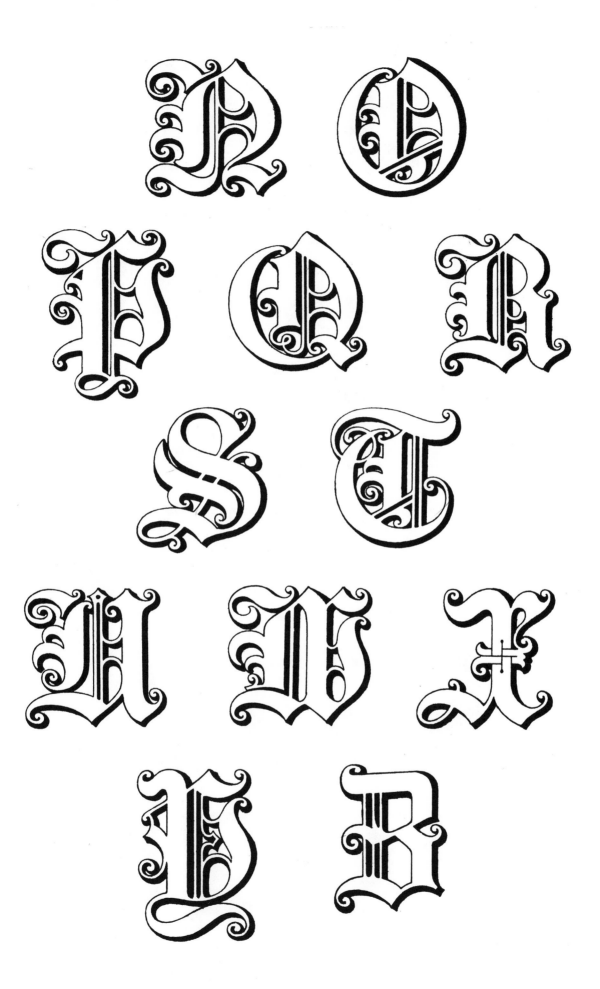

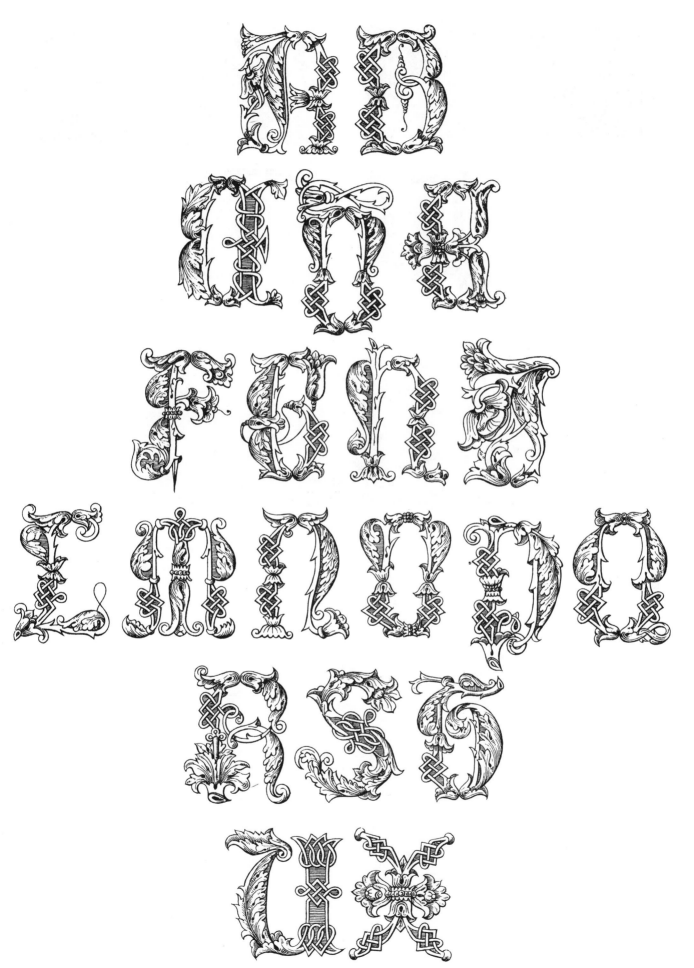

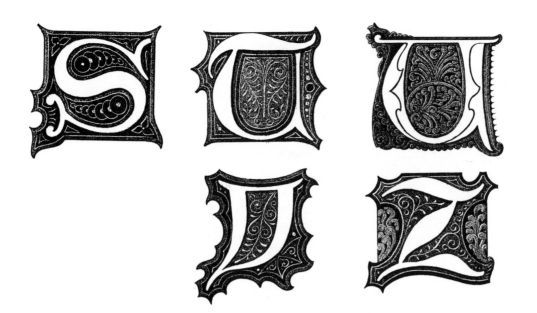

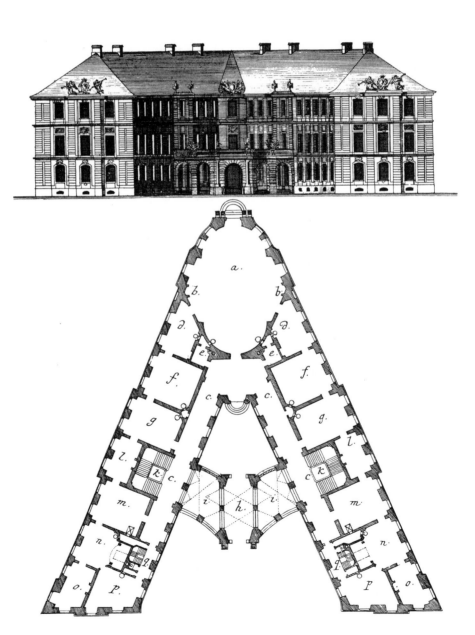

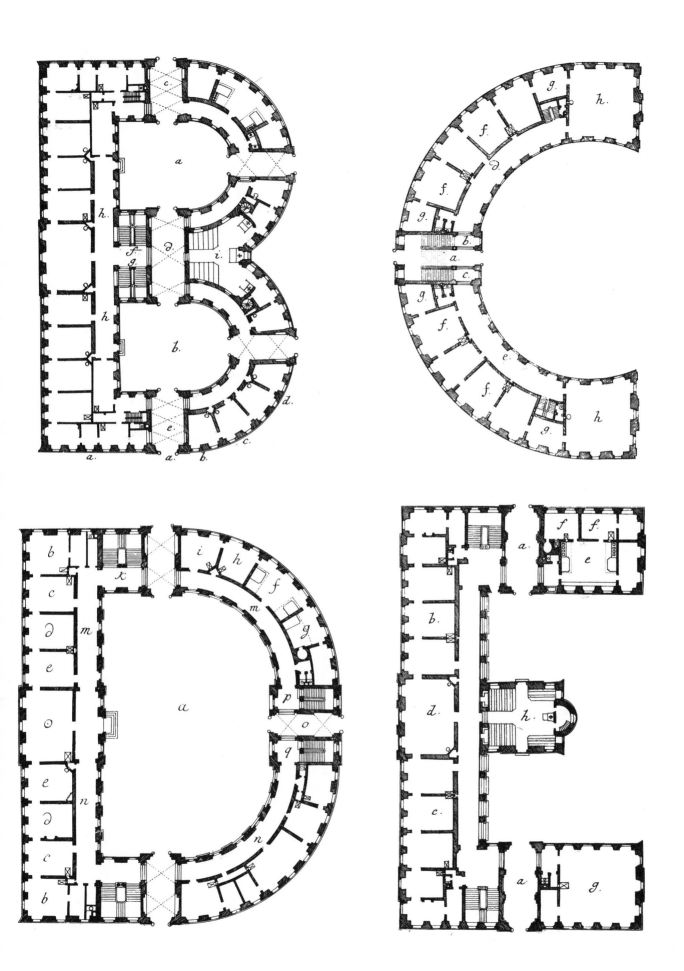

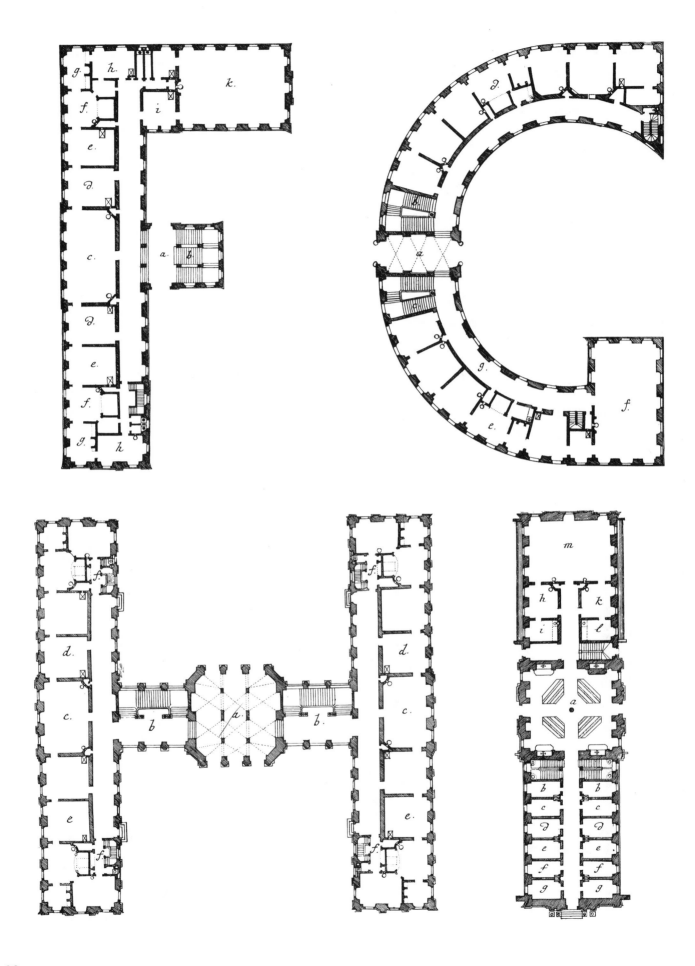

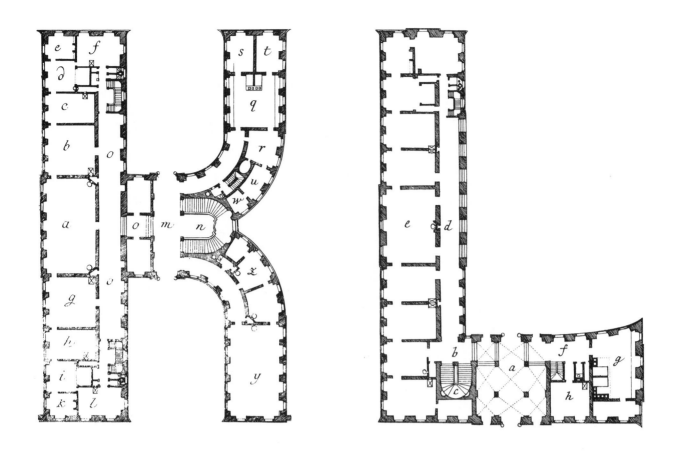

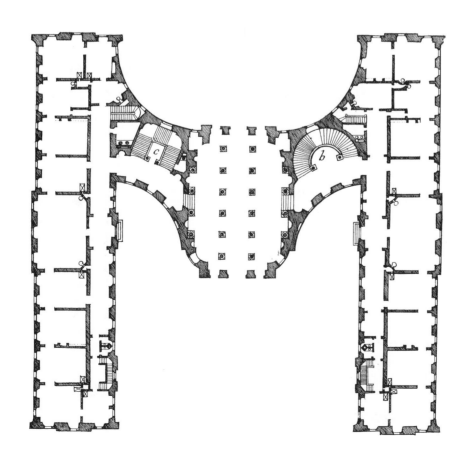

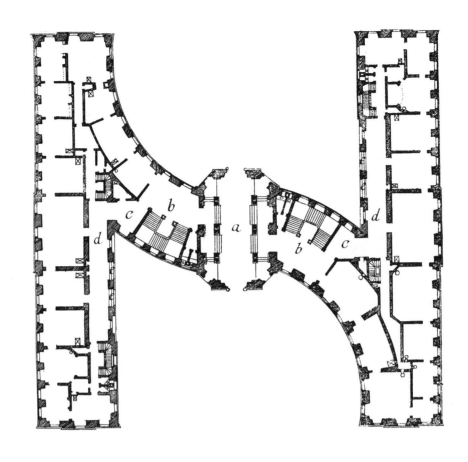

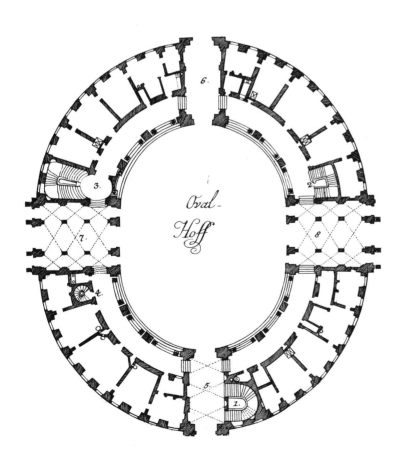

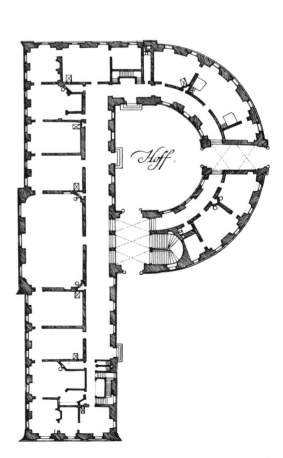

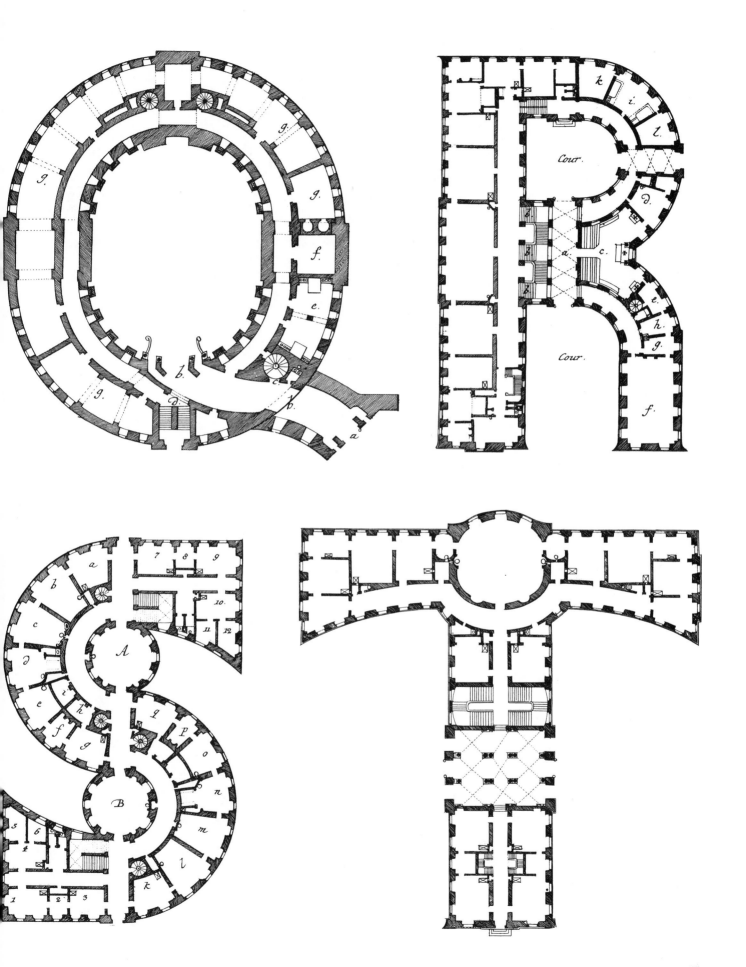

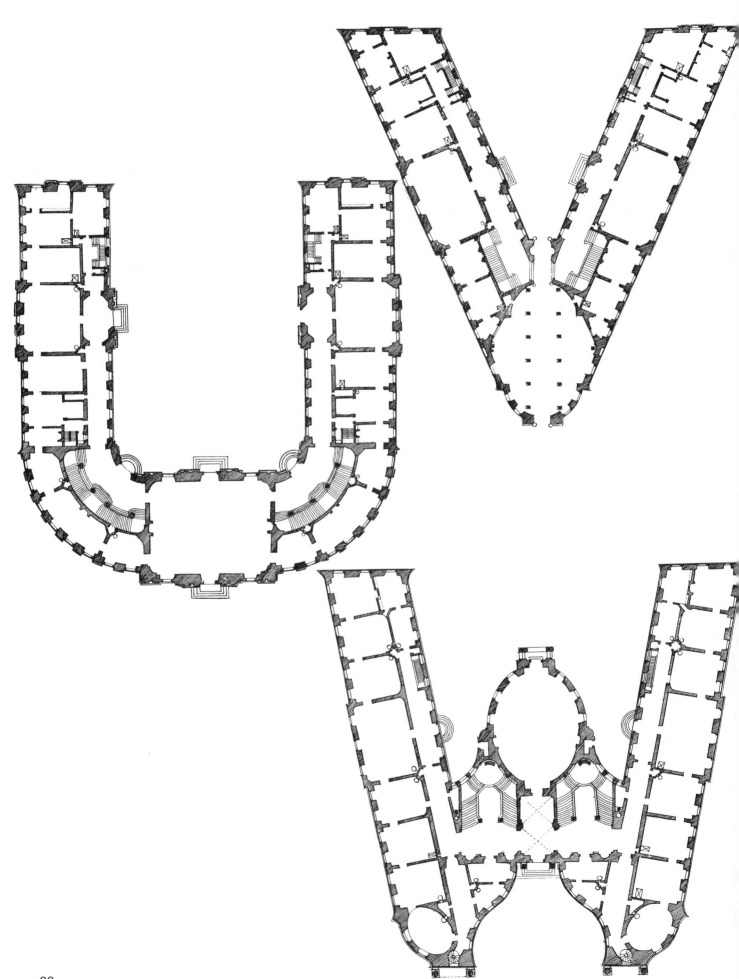

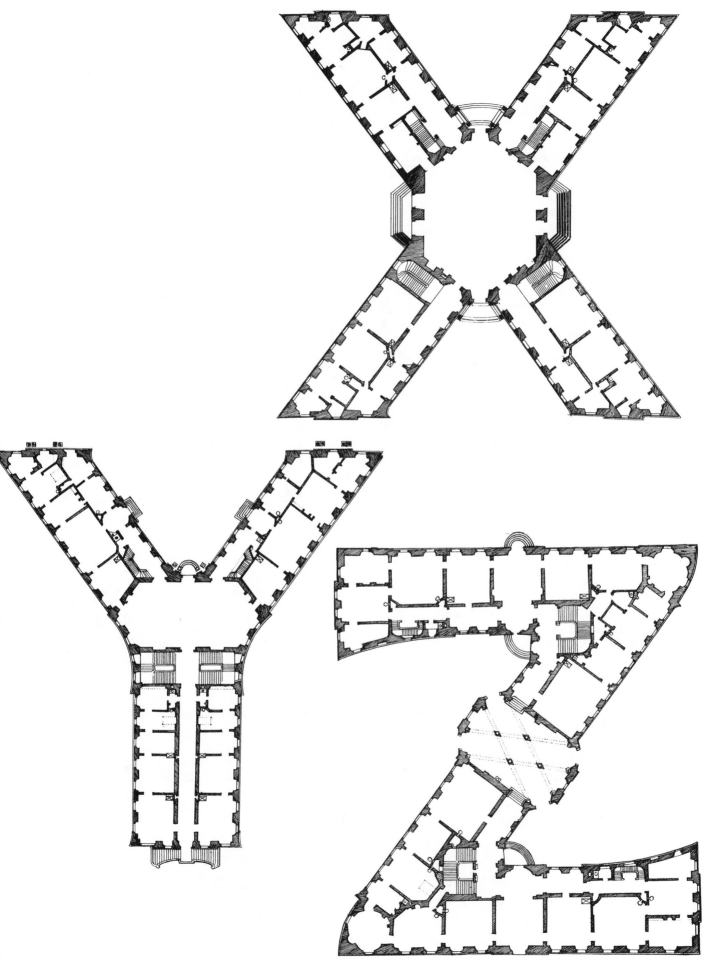

91

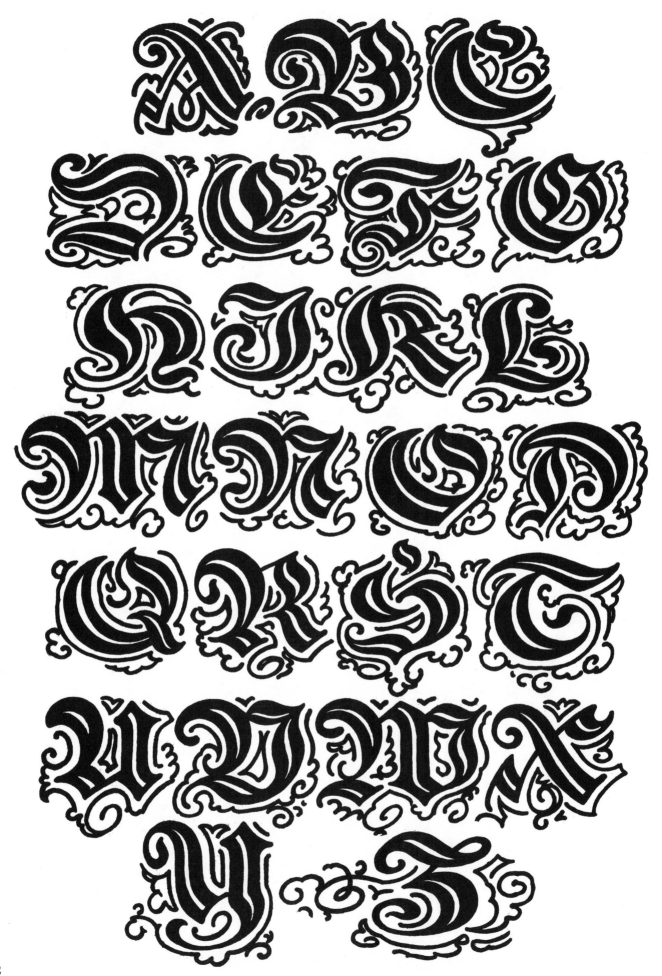

A B C
D E F G
H J K L
M N O P Q
R S T U
V W X
Y Z

ABC
DEFG
HIJKLM
NOPQR
STUV
WXY
Z

A B C
D E F G
H J K L M
N O P Q
R S T U
V W X
Y Z

A B C D
a b c d
E F G H I
e f g h i
K L M N
k l m n

OPQR

opqr

STUV

stuv

WXYZ

wxyz

ABC
DEFG
HJKL
MNOP
QRST
UVWX
YZ

A B C D
E F G H I
K L M N
O P Q
R S T U
V W X Y
Z

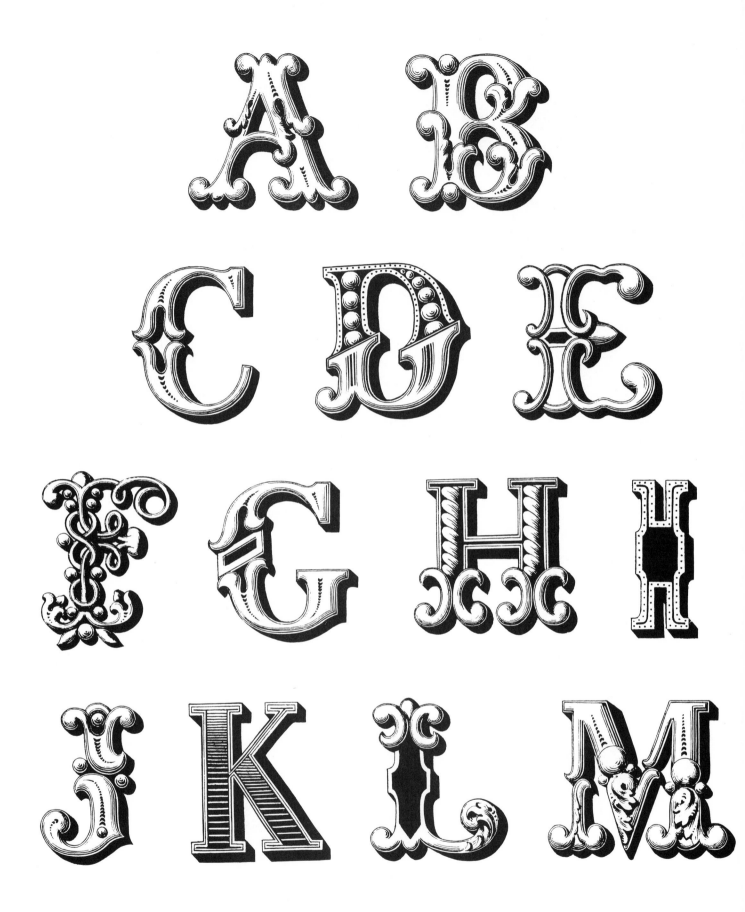

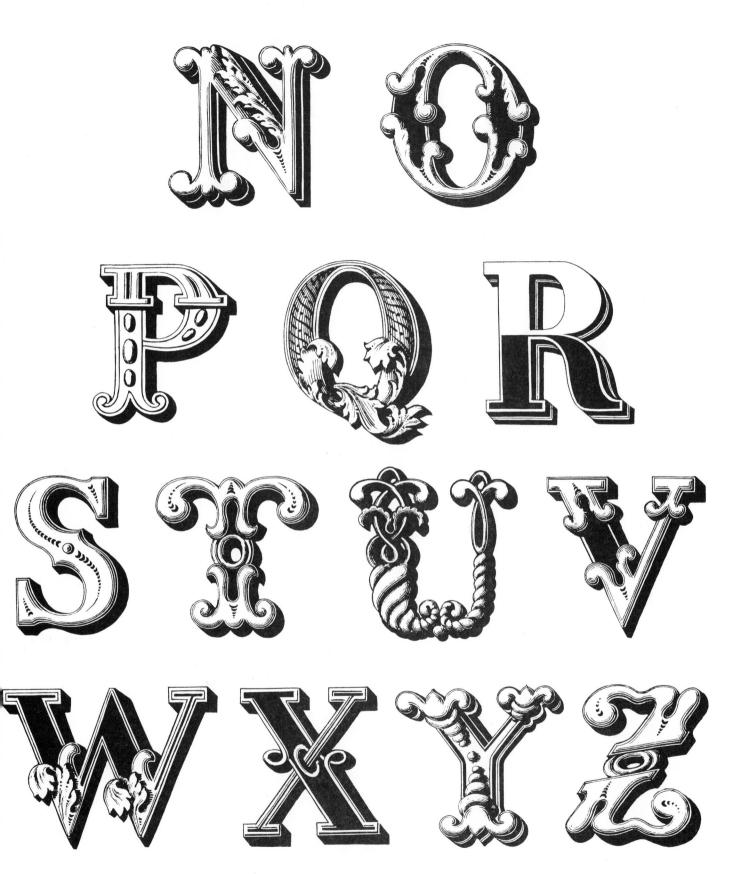

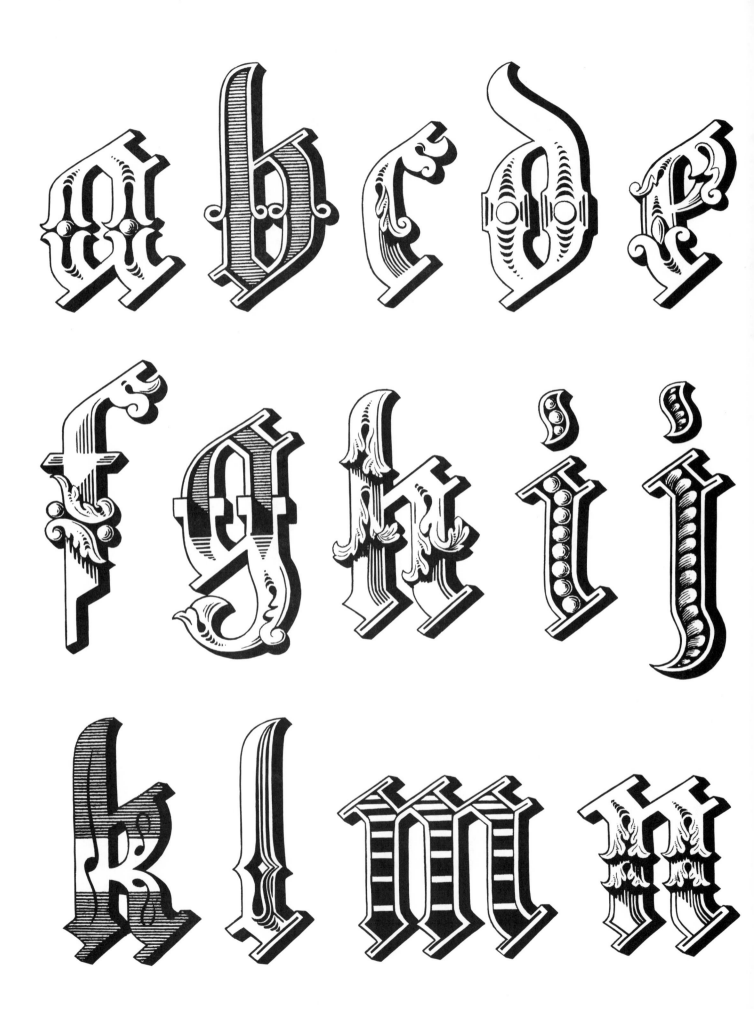

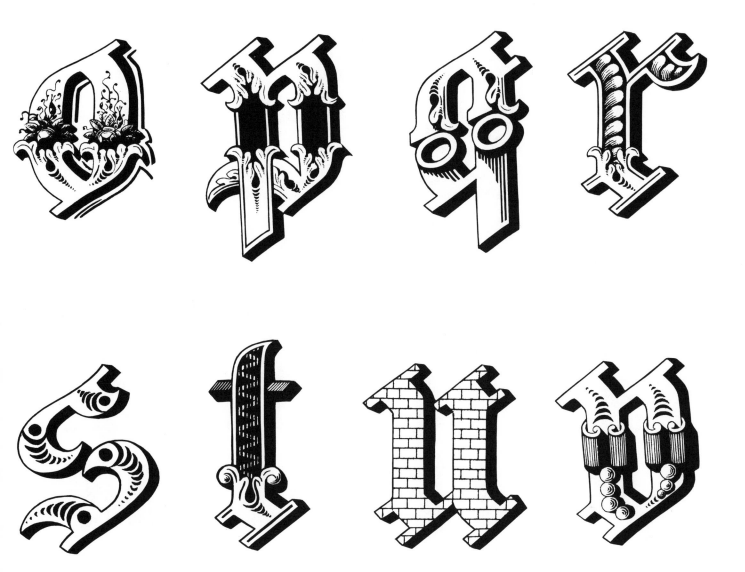

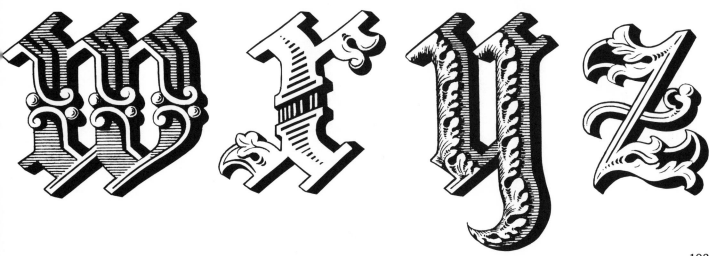

A
B C D
E F G H
I J K L M
N O P Q R
S T U V
W X Y
Z

ABC
DEFG
HIKL
MNOQ
RST
UXY
Z

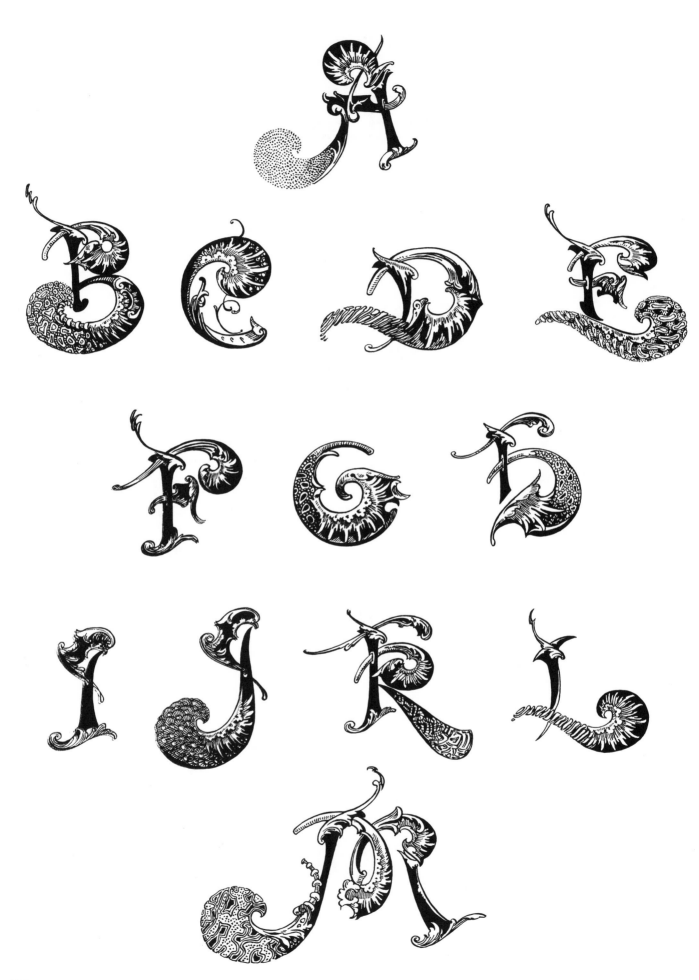

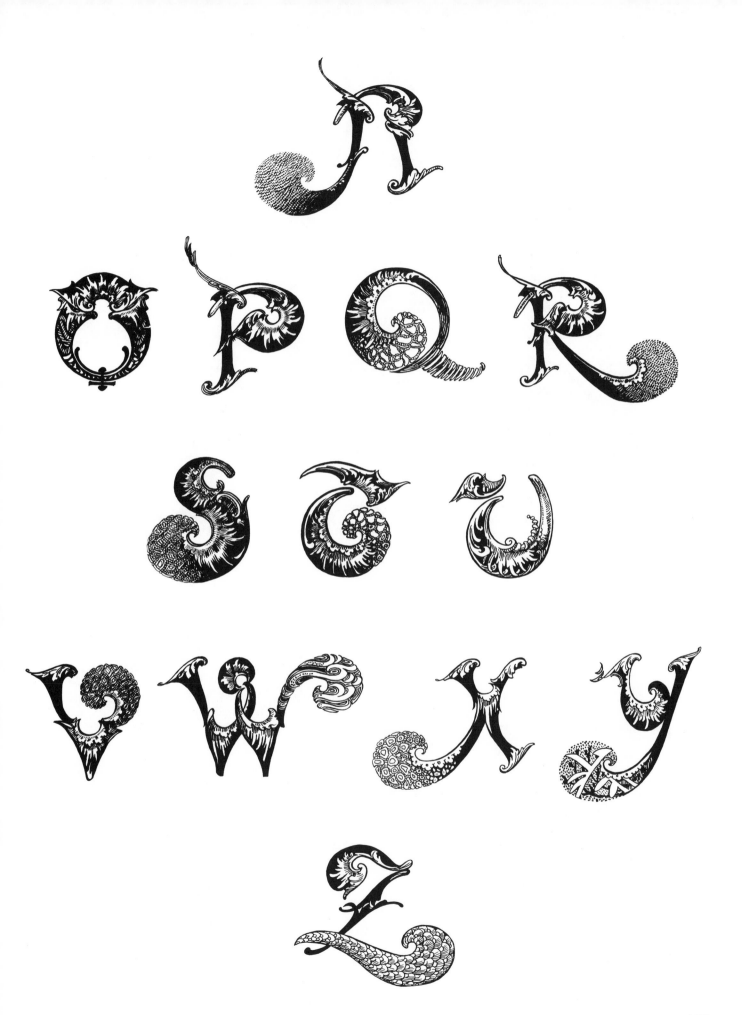

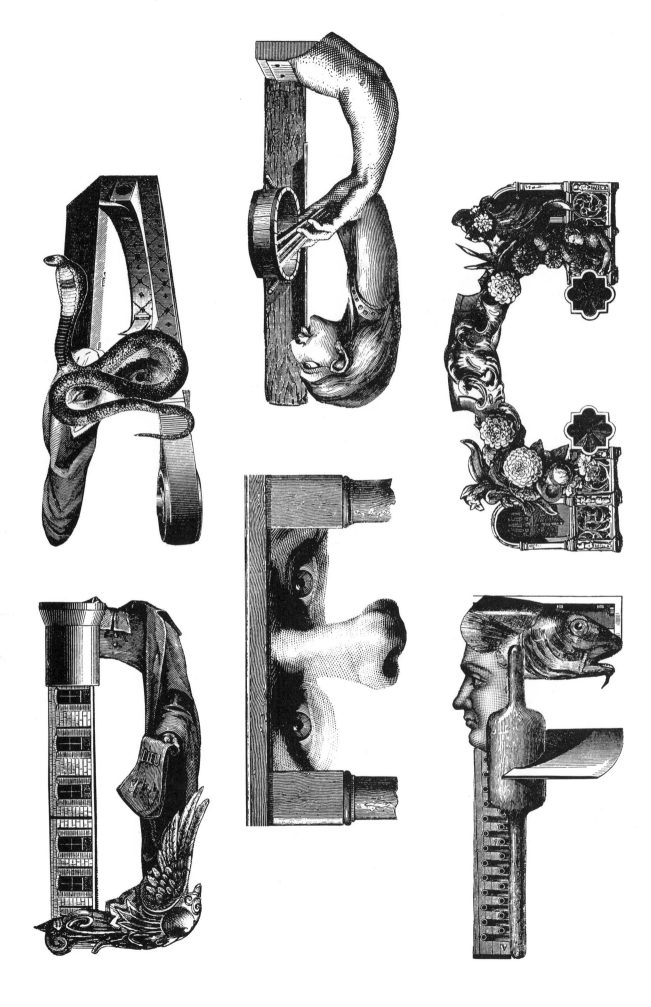

108

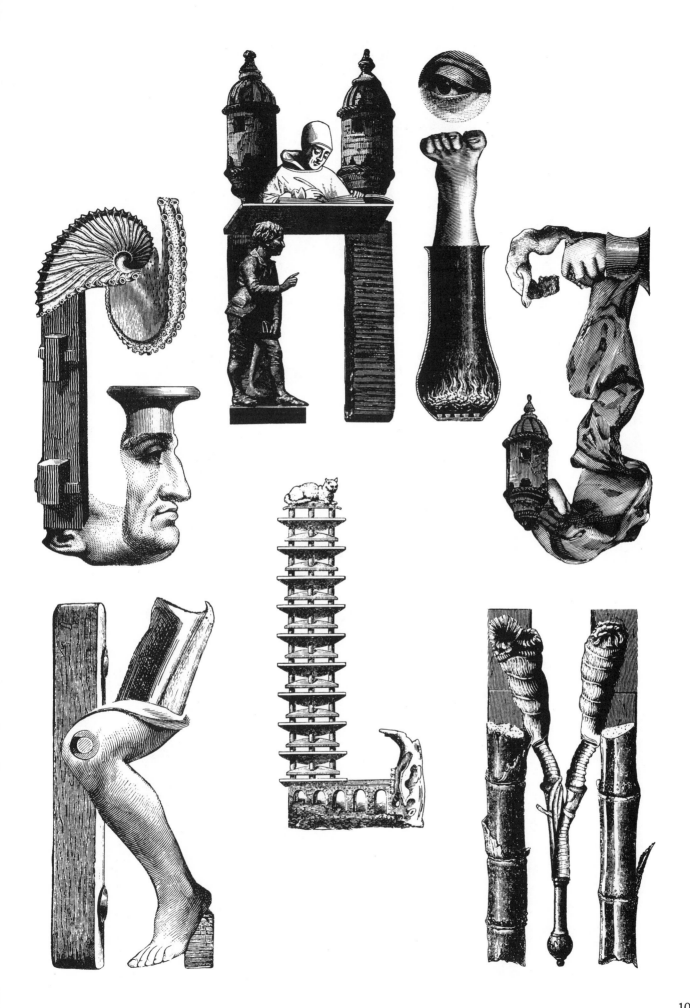

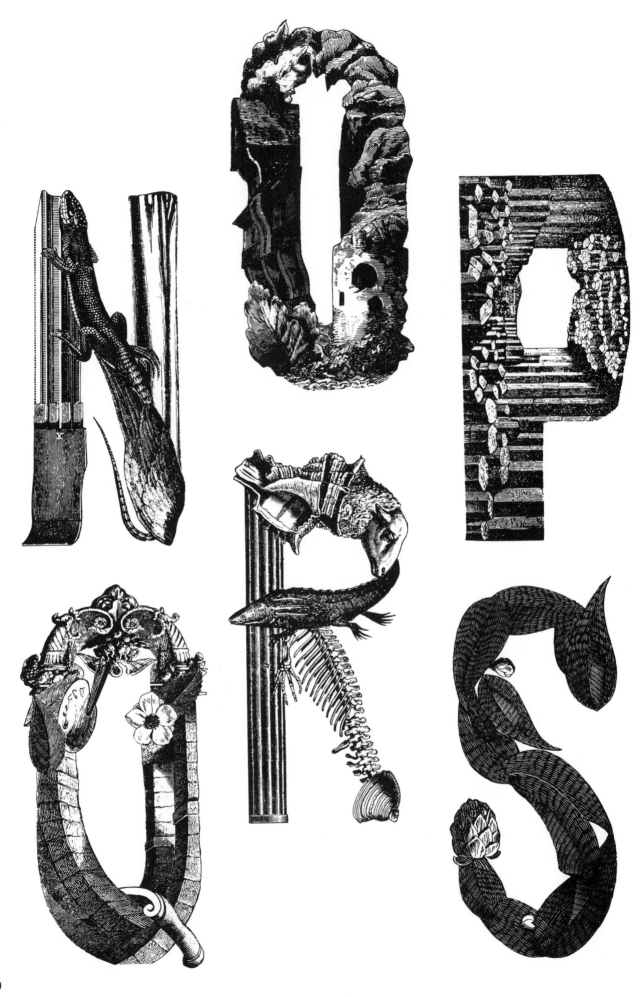

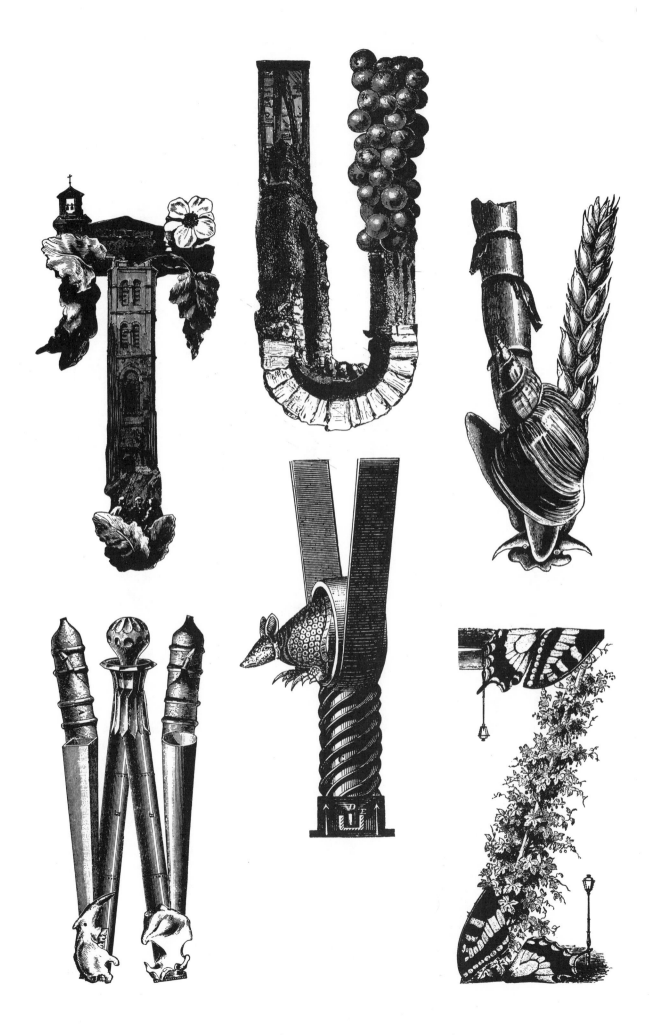

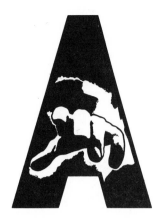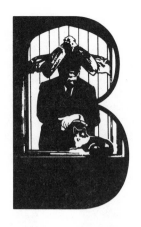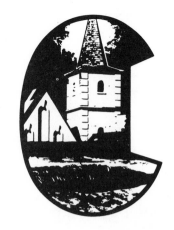

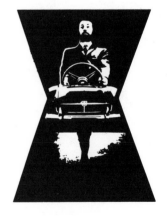

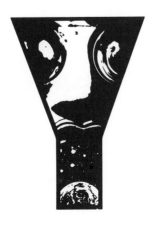
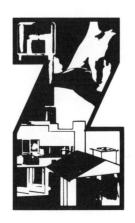

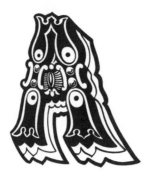

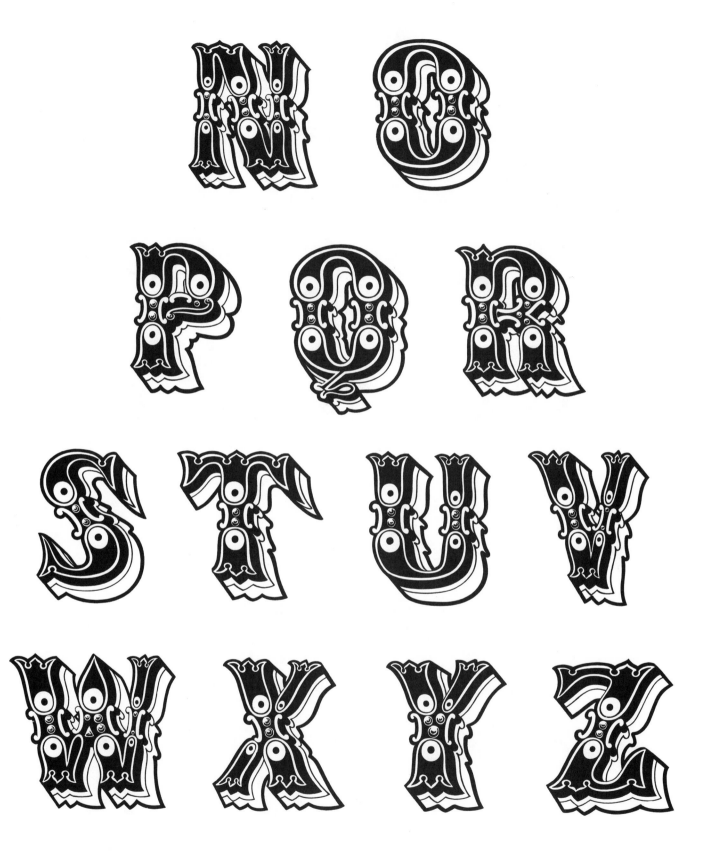

ABC
DEFGHI
KLMN OPQR
STUVWXYZ

ABC
DEFGHJ
KLMNOPQR
STUVWYXZ

ABCD
EFGHIJKLM
NOPQRSTUV
WXYZ

AB
CDEF
GHIKLMN
OPQRSTU
VWXYZ

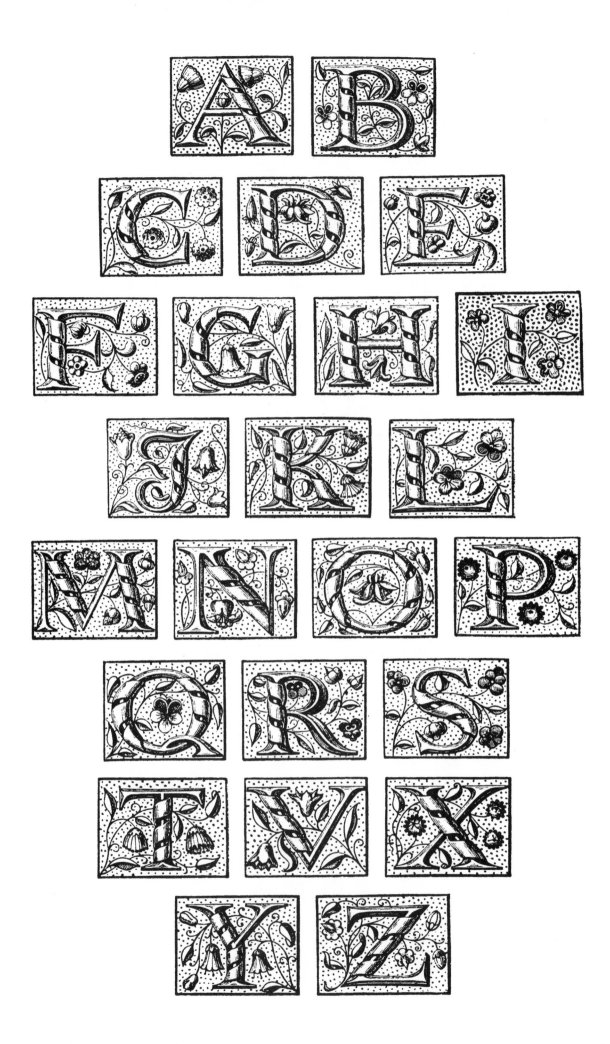

ABCDEF
GHIJKL
MNOPQ
RSTUV
WXYZ

A B C D
E F G H I
J K L M
N O P Q R
S T U V
W X Y Z